101

Techniques

Acrylics

BARRON'S

101

Techniques / **Acrylics**

In artistic matters, the theory must come after, and be brought along by, the practice. General ideas about painting practices have little value if you have never taken a brush in hand and swept it across a canvas. No explanation, no general idea can take the place of the act of painting. This, then, is a book designed for the reader to learn to paint through practice: we know that based on this you will be able to make up your own mind about painting practices.

The lessons in this book are essentially exercises. After a section on the typical materials for painting with acrylics, there are a large number of exercises that show how to paint with this medium. The techniques that are presented here could be many more, or many fewer, than the 101 possibilities shown. There could be many fewer because, in essence, all you need are a brush, some canvases, some paint, and a vague idea of painting to begin working and learning as you go. There could also be many more because, as any experienced painter well knows, each subject and each new painting require a new approach, however simple it may be. In each painting, the intention, the spirit, and the personal attitude change. A true artist never stops discovering and learning. The 101 approaches collected here constitute the most complete compendium of possible techniques after combining the different thematic and stylistic factors with the possibilities and capabilities of acrylic paint. Thus, each exercise is an encounter between a subject, a technique, and a particular style. Throughout we have made sure that the variations of theme, technique, and style are as meaningful as possible.

The order of the sections is strictly functional and responds to the need to organize the exercises in a way that matches the needs of each exercise. It is not necessary to follow the exercises in the order we have placed them; you can choose any order you wish, moving forward and back, as you wish.

Each exercise is a step-by-step sequence that occupies one or two pages. The level of difficulty has nothing to do with its length. This factor is expressed with the use of one or two stars. One star means that the technique is within the abilities of a beginner; two stars mean that the exercise is meant for a painter with somewhat more experience. But beginners are encouraged not to skip the two-star exercises because they can learn as much or more from the more difficult exercises. The golden rule for all beginners is to always try something that is a little beyond your abilities. And we are certain that artists who know acrylics well will be surprised more often than not by discovering simple approaches ("one star") to subjects that at first glance do not seem complicated.

This book was written by a team of professionals who have many years of experience teaching drawing and painting. This experience has guided us in creating this course, and we hope that it will be of good use for beginning and experienced artists alike. At all times, we have wished to bring you clear, direct, and accessible information that at the same time is visually diverse and attractive. We are sure that readers will not overlook these values.

Contents

Beginner Level ★ Advanced Level ★★

Acrylic Paint

Acrylic paints are manufactured with powdered pigments and agglutinated with a water-based solution of polyvinyl acrylate, a polymer that allows the pigment to be held in suspension. When the water evaporates, the acrylate particles trap the pigment particles and form a film that is hard, transparent, and waterproof.

It is a very flexible and durable paint. The pigments used to make it can be organic or inorganic. Organic pigments are found in nature: raw and baked earths and powdered minerals. Inorganic pigments are created by chemical processes. In both cases, the substances are very stable, and they can be combined with each other. The price of the paints will vary based on their availability and how difficult they are to obtain. The raw earth tones are the least expensive.

Kinds of Paint

Every manufacturer supplies color charts that show all the colors they sell, and whose names vary quite a bit from one manufacturer to another. Paint colors with the words *cobalt*, *cadmium*, *titanium*, and *phthalo* (the abbreviation of phthalocyanine, an organic pigment), indicate the kind of pigment in the paint. The word *permanent* indicates a mixture of several pigments that create a stable intermediate tone. The majority of the acrylic paints are transparent when they are diluted, but many are opaque when used directly from the tube.

Recommended Range of Colors

In this book, we will use a range of colors that is wide enough to serve as a departure point for any artist. It consists of the following colors shown in the image below (from left to right and top to bottom): lemon yellow, cadmium yellow, permanent red, raw sienna, ochre, permanent green, sap green, ultramarine blue, phthalo blue, cobalt violet, ivory black, carmine, burnt umber, cobalt blue, and titanium white. The colors on this palette can be mixed to create many other tones. With experience, you will discover other colors that you like to use, and some on this list will turn out to be unnecessary or wrong for you.

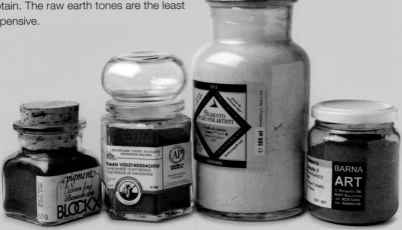

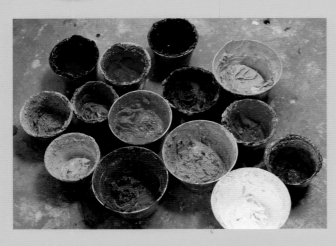

Pigments can be of organic (natural) or inorganic (synthetic) origin. The price of the paint will vary according to the availability and cost of obtaining each pigment.

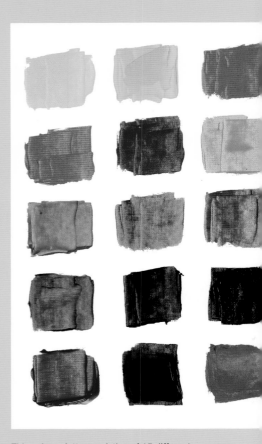

This color palette consisting of 15 different tones are those that will be used in this book.

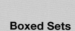

Containers

Acrylic paints are available in plastic tubes and in jars with a screw cap or an applicator. Since the paint dries so quickly and it is waterproof after it has dried, it is easy to lose small amounts of paint that are not used in each painting session. For this reason, the containers for acrylic paints are larger than those that contain oil paints, for example. It is a good idea to always have an extra amount of white because it is very useful for covering dry areas that you wish to paint over, and for painting base coats with or without textures.

Boxed Sets

Paint boxes are a normal part of a painter's equipment. They are wood cases that are sold empty or with a selection of paints, brushes, and solvents. The sizes and quality vary, from student boxes to the very expensive large studio box made of fine hardwood. All of them are used for transporting tools and materials, so they are not required for painters that work exclusively in the studio, although they help keep the equipment neat and organized.

Palettes

When mixing colors, all you need to have at hand is a nonabsorbent surface, like porcelain, varnished wood, or plastic. It is important to clean the palette well after each session because it is difficult to mix colors over the dried paint. Some companies make palettes with disposable, waxed sheets of paper to make cleanup easier.

Acrylics are usually sold in metal or plastic tubes.

The surface for mixing paint should be smooth and nonabsorbent; plates and other ceramic surfaces work very well for this. Palettes with disposable sheets are a good alternative to more conventional palettes.

Jars with applicators are very popular among artists. Acrylic paint does not cover as well as oils paint does so a greater amount of paint is generally needed.

Materials / **Brushes**

Natural Hair

Natural hair for brushes is generally obtained from mammals, members of the Mustelid family, and hogs. Hog bristle brushes are a necessity when painting with acrylics. The best bristles are long and durable, and are obtained from a variety of Chinese pig. Hog bristle brushes can hold a large amount of paint without becoming limp, and they are good for painting heavy impastos.

Synthetic Hair

Synthetic brushes are made with artificial fibers, and are softer than hog hair although they are stiff enough to render good results in work requiring a lesser amount of paint and a smooth finish. They are nearly indispensable for painting with acrylics because the wet nature of the medium works well with the texture and flexibility of this kind of brush. Their usefulness especially stands out in the round brushes with pointed tips, which allow you to make thin and precise lines.

Shapes

The two basic shapes of the hair of paintbrushes are round and flat. The round brushes have a fine tip, and the flat ones are square, with a straight edge. Generally, round brushes are used for making lines and long brushstrokes, while the square ones are better for applying thick paint. There are also flat brushes with pointed tips, known as filberts, but they are not used nearly as much as the square ones. All brushes made for painting with acrylics have long handles to make it easier to work a certain distance from the support, and they are usually always longer than those normally used for painting with watercolors.

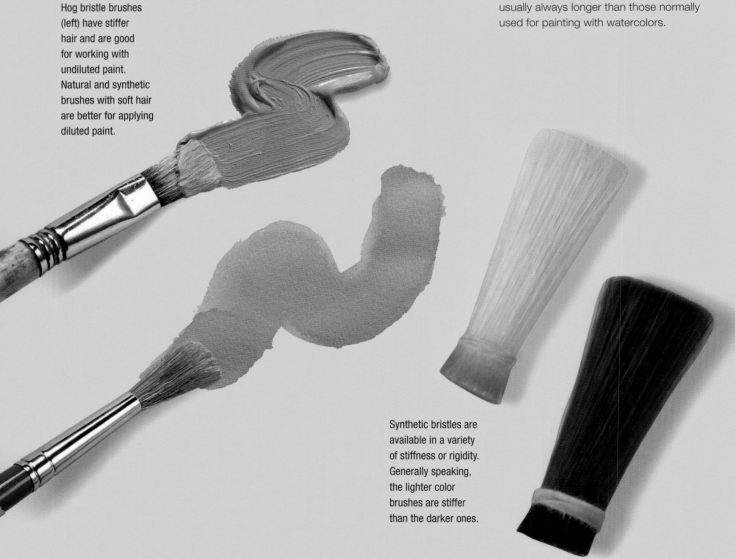

Hog bristle brushes (left) have stiffer hair and are good for working with undiluted paint. Natural and synthetic brushes with soft hair are better for applying diluted paint.

Synthetic bristles are available in a variety of stiffness or rigidity. Generally speaking, the lighter color brushes are stiffer than the darker ones.

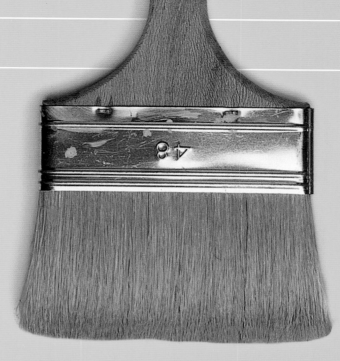

Recommended Selection

A good selection of brushes would at least consist of three of each type. This means that you should have three round hog bristle brushes (fine, medium, and large), and another three round ones with synthetic hair. In addition, you should have three flat brushes (narrow, medium, and wide) with synthetic hair and another three with hog bristles. This is the selection we will use in this book, with an additional very fine round brush for painting particularly small details.

It is important to have one or more flat wide brushes for painting backgrounds and applying large areas of color.

Wide Brushes

Whether round or flat, these big brushes are used for painting large areas of color. It is a good idea to have a flat brush for painting backgrounds and applying base coats on the support.

Maintenance

Brushes used with acrylic paint should be washed after each session. First, you must remove excess paint from the bristles with a rag or a piece of absorbent paper, like newsprint, for example. Then, rinse the bristles in water to remove as much paint as possible. Finally, wash it with liquid or bar soap. A brush with dried acrylic paint in it will no longer be useful.

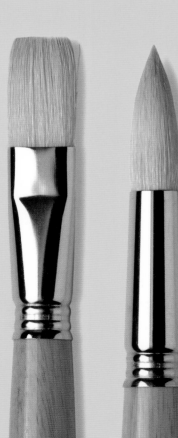

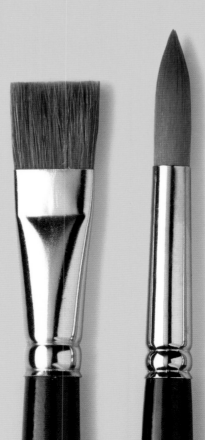

Medium and large flat brushes, natural or hog bristle, are normally used more than small ones. The tips of round brushes, whether hog bristle or synthetic, are very good for making lines. Your selection should include several different sizes of each kind.

Fabrics

Fabric or canvas is the traditional support for acrylic paintings. Different fibers are used in their manufacture: linen cotton, and jute or burlap. The best quality canvases are made of linen because they are fine and react well in damp environments. They absorb a lot of humidity, but it evaporates very quickly, so the tension of the stretched fabric does not vary by much. Cotton works well, although it is not as stable and durable as linen. Many manufacturers make canvases of mixed linen and cotton fibers to create a quality fabric at a good price. The burlap and jute fabrics are heavier, can be quite rough, and are appropriate for large-scale works with heavy impasto. Canvases are sold mounted on stretchers or in rolls, and the fabric can be raw or already primed.

Generally, all raw canvases must be prepared with an acrylic primer like gesso or a similar product before being used.

Fabric is the most commonly used support for acrylic paintings. They can be bought with a primer coat applied at the factory, but they are also available raw so they can be prepared to each artist's specific requirements.

Primers

Canvases require a primer or preparation before they can be used, unless you prefer a rough finish. The primer coat protects the fibers and reduces or removes excessive absorbency. The preparation can be applied to the raw canvas by the manufacturer or by the artist. All prepared canvases can be trusted. Some prepared canvases are specifically for oil painting and cannot be used with acrylics, so you must make sure that you are buying fabric with a universal primer or one that is specifically meant for acrylics.

Gesso is a white water soluble paste. It is used as a primer coat on surfaces that are too porous to be painted on directly.

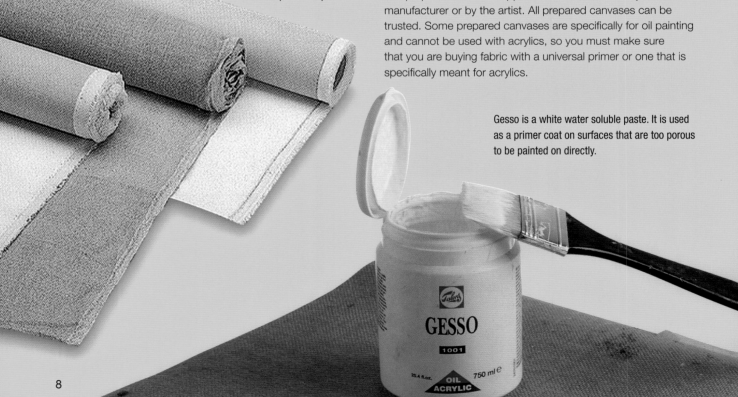

Stretched and Mounted Fabrics

Stretchers are simple wood frames that have wedges and sometimes cross braces on the larger sizes. They are used to stretch the fabric tightly, and there are many different kinds, the heaviest ones being the most expensive. They come in standard sizes and in three basic shapes: figure (standard format), landscape (horizontal), and seascape (longer and horizontal). Today the options have become so diverse that we can barely talk about standard sizes. In this book, we will use stretched canvases in the figure or vertical format, of a size around 16 × 24 inches (41 × 61 cm).

Canvas Boards

Canvas boards are made of wood or heavy cardboard with fabric attached to one of its sides. It is a rigid support that works well in medium and small sizes.

Papers for Acrylic Paint

These papers are manufactured from a mixture of natural and synthetic fibers that accept the damp and thickness of acrylic paint without absorbing it and almost without buckling. The medium and small ones work quite well, and they are available as individual sheets, tablets, and rolls.

Stretchers, with or without canvas, are sold in different sizes and proportions and are a necessary item if you are painting on fabric.

These are primed fabric glued to boards. They are very useful rigid supports when you are working with medium to small formats.

Papers made for painting with acrylics are sold in tablets and individual sheets. Their surface is especially designed for accepting acrylic paint without buckling with the dampness.

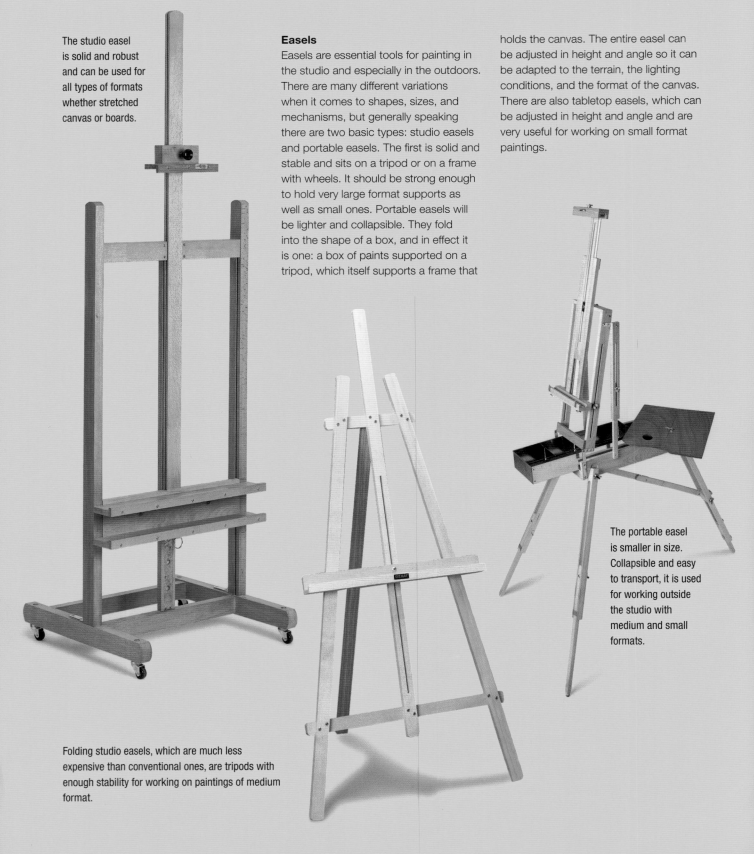

The studio easel is solid and robust and can be used for all types of formats whether stretched canvas or boards.

Easels

Easels are essential tools for painting in the studio and especially in the outdoors. There are many different variations when it comes to shapes, sizes, and mechanisms, but generally speaking there are two basic types: studio easels and portable easels. The first is solid and stable and sits on a tripod or on a frame with wheels. It should be strong enough to hold very large format supports as well as small ones. Portable easels will be lighter and collapsible. They fold into the shape of a box, and in effect it is one: a box of paints supported on a tripod, which itself supports a frame that holds the canvas. The entire easel can be adjusted in height and angle so it can be adapted to the terrain, the lighting conditions, and the format of the canvas. There are also tabletop easels, which can be adjusted in height and angle and are very useful for working on small format paintings.

The portable easel is smaller in size. Collapsible and easy to transport, it is used for working outside the studio with medium and small formats.

Folding studio easels, which are much less expensive than conventional ones, are tripods with enough stability for working on paintings of medium format.

Palette Knives

Palette knives, painting knives, or spatulas are irreplaceable as tools for manipulating paint, spreading it, applying it to the canvas, and also scraping off excess paint or cleaning the fabric. Painting with the palette knife occupies its own distinguished place in the practice of art. Palette knives in the shape of a trowel, the typical mason's tool, are the best ones for working with acrylics; they will allow you to apply, spread, and drag large amounts of paint around the canvas. The ones shaped like knives are more flexible and are used for cleaning the palette by scraping off the paint. Finally, the larger palette knives with rectangular and triangular shapes are not as flexible as the others; they are used for spreading mixtures that are very thick or that incorporate fillers.

Acrylic Medium

Acrylic paints are diluted with water. Some artists add acrylic medium, which is the vehicle for acrylic paint, to the water to increase the fluidity of the paint, although it is not necessary to do so. Acrylic medium can also be used instead of water when you want to use thick paint; it will allow the brush to glide easily across the surface of the support. In this book, we will show an example of this application.

A container of masking fluid.

Masking Fluid

Masking fluid is also referred to as masking liquid. It is a yellow liquid that is used to reserve small areas of white (or the base color) in a painting. It is applied with a brush and adheres to the support, creating a thin protective film that can be easily removed by rubbing with a finger after the work of art is finished.

Trowel-shaped painting knives let you apply paint very precisely. They are also used for scraping and cleaning the palette.

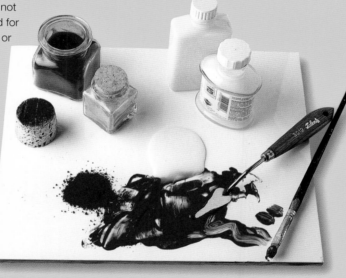

Acrylic medium is a milky liquid that becomes transparent when it dries. It is the vehicle for acrylic paint and is used for increasing the fluidity of the paint and for creating your own artisanal paints.

The larger rectangular and triangular painting knives have straight edges, which allow large amounts of paint to be spread easily.

Primers

Primers are also referred to as preparations or base coats. These substances are spread on a fabric, cardboard, or wood support to create a surface that will accept paint. Primers create a base with the right amount of absorbency, adhesion, and texture for accepting the paint. Today you can buy any kind of primer ready to be used. Artists that prepare their own supports generally use a synthetic primer with an acrylic gesso base, a white paste that is easily diluted with water. In this book, we will use a traditional preparation based on casein, a white powder that is mixed with water and spread on the support to give it an absorbent matte finish, ready for certain kinds of work.

Fillers

Fillers are substances added to the paint that alters its consistency and texture, but not its color. Many artists use it to add a personal character to their work, a particularly rough material quality that evokes painted murals or stone surfaces. Only totally inert fillers should be used, that is, they should not decompose or cause undesired chemical reactions in contact with the paint. The amount of filler and its granularity will determine the texture of the paint. Too much filler will affect the adhesion of the paint. The most common fillers are ground pumice stone, marble dust and sand, rinsed river sand, and sawdust, among many others. Here we will also use ground cork.

Acrylic paint with marble sand.

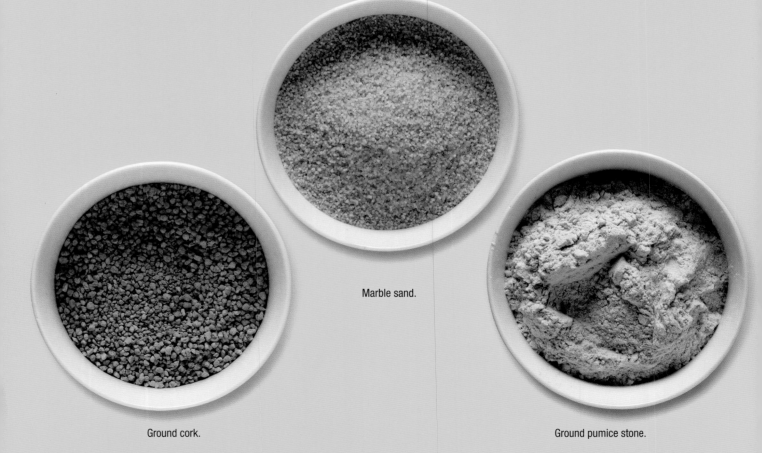

Marble sand.

Ground cork.

Ground pumice stone.

Gels and Varnishes

There are many additives for acrylic paint. Some of the most common are gels, more or less viscous pastes that can be equally used for preparing supports and for mixing with paint. When they dry, they continue to maintain the relief that allows you to create ridges and thick areas in the paint layer. They are transparent unless mixed with white paint. They can create interesting effects, for example that of a very delicate and transparent color with an exaggerated amount of relief.

Varnishes are applied over finished, completely dry paintings. They create a protective film that isolates the paint from the atmosphere and causes it to lose its "bite" or adhesiveness, which keeps the paint layer from sticking to another surface when the work is stored. It is available with a matte or a glossy finish.

Additives

These are sold under the name of mediums, and they are used for several different purposes. Some increase the fluidity or creaminess of the paint. Others increase its transparency, or will accelerate or retard its drying time, and others will modify a painting's natural matte or glossy finish. Their use is not required; only practice and continuous experimentation will allow the artist to discover whether he or she needs to use any kind of medium or not.

Most manufacturers offer acrylic pastes with incorporated fillers, ready to be mixed with paint.

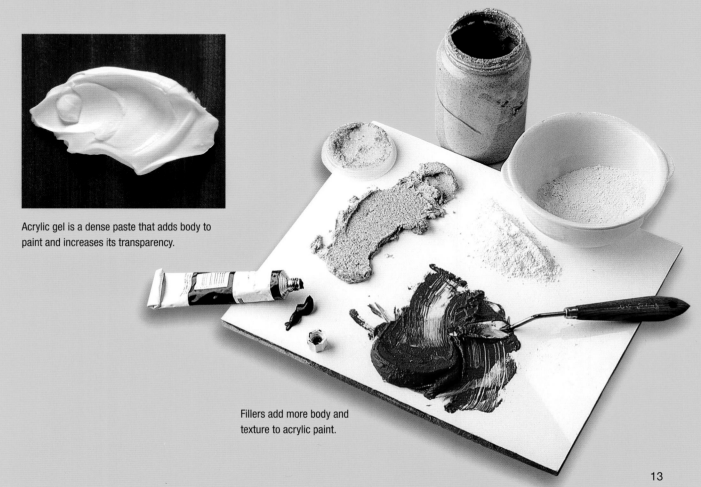

Acrylic gel is a dense paste that adds body to paint and increases its transparency.

Fillers add more body and texture to acrylic paint.

LEVEL OF DIFFICULTY
★
COLORS
Carmine
Phthalo Blue
Ivory Black
Titanium White
BRUSHES
Medium Flat Synthetic Hair
Fine Round Natural Hair
SUPPORT
Canvas Board

White makes colors opaque. Any transparent color becomes denser when it is mixed with white. In this example, we are going to use this quality to create a glazed effect to represent the snow and the ice on the ground of a winter landscape.

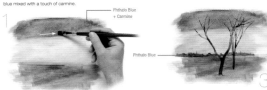

1. With the flat brush, paint the background on a three-strip configuration. The lower one is carmine mixed with a small amount of blue, considerably diluted; the middle is very light blue because we have mixed it with a large amount of white; and the upper one is blue mixed with a touch of carmine.

Phthalo Blue + Carmine

Phthalo Blue

2. With the round brush charged with black somewhat diluted in water, draw the trees carefully letting the silhouette remain transparent against the color of the background.

Ivory Black

3. With the same brush now charged with black paint, the narrow band of the horizon in which we can perceive the silhouettes of several buildings.

4. Create a glazed effect on the foreground by applying white, not very thick, over it. The resulting effect is that of a coat of snow that lightly reflects the violet tone of the winter light.

28

LEVEL OF DIFFICULTY
★
COLORS
Cobalt Blue
Magenta
Titanium Blue
Permanent Green
Lemon Yellow
Titanium White
BRUSH
Wide Flat Synthetic Hair
SUPPORT
Canvas Board

The opacity of acrylic colors makes it possible to work with masking tape or reserves on some areas of the support. Masking tape is adhesive tape that protects an area of the painting so that you can create sharp silhouettes or a particular color or the background color.

A simple way to create a stencil is to place several pieces of masking tape together one after the other and to draw the shape that you wish to cut out over them. Cut out the shape with a cutting blade, lift it from the support and adhere it to the support.

Magenta + Titanium Blue

1. Adhere the masking tape shape of the vase to the support, then paint the background with a thick and opaque mixture of magenta and titanium white.

2. When the paint is dry, place the masking tape of the vase part over the magenta background and part over the previous mask.

3. Paint the outside of the stencil with undiluted cobalt blue. The opacity of this color covers the magenta completely.

Cobalt Blue

4. Once the is dry, peel masking tap reverse ord last one firs

6. We only to paint the that is white permanent mixed with amount of lemon yellow.

Permanent Green + Lemon Yellow

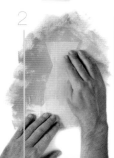

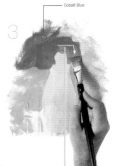

34

35

The inset page shows:

12 Transparent Color / **Transparencies and Drawing**

LEVEL OF DIFFICULTY
★ ★
COLORS
Cobalt Blue
Yellow Ochre
Permanent Green
Titanium White
Ivory Black
BRUSHES
Wide Flat Synthetic Hair
Fine Round Synthetic Hair
SUPPORT
Stretched Canvas

In this exercise, the transparency has an impact on the theme because the bird represented here is also transparent since the color of the background emerges through it. But the result is not exaggerated, it is consistent with a procedure that is quite common, which is to separate sharply drawing from color.

1. Paint a large area of cobalt blue lightened with white over a basic drawing of the bird. Apply the color diluted with water, as needed, to allow the brush to glide easily on the support.

— Cobalt Blue + Titanium White

2. With the thin brush, draw the feathers with white and gray (mixture of black and white) paint.

3. The gray lines are more predominant in the rear and lower areas, which are more shaded; in those areas, the lines should be thicker. The bird's legs are painted with opaque black, and the branch and leaves are painted with ochre and green.

4. Finish the last details. The result is very fresh and lively. This technique can be used to enhance works based on drawings.

Titanium White
Ivory Black

29

Adding color to the painting

The 101 Techniques

This section is organized in ten large blocks or monographic sections, each one of them consisting of between seven and twelve practical examples that demonstrate variations and approaches using a characteristic technique of acrylic painting.

Each exercise incorporates information about the materials that are used: colors, size and quality of the brushes, palette knives, and kinds of supports. In addition, all the exercises indicate their level of difficulty using one or two stars. One star indicates a beginning level: it means that the exercise is appropriate for a beginner. Two stars indicate an advanced level: the exercise is meant for a painter with somewhat more experience.

The development of the painting is related in step-by-step sequences that fill two pages. In a few cases, two different techniques are explained in a single exercise, and the painting is finished within the four pages. The explanations of each step are supported with indications about the colors that are being used from moment to moment and place to place in the work, and the movement of the brush is indicated with arrows at appropriate times.

LEVEL OF DIFFICULTY
★
COLORS
Ultramarine Blue
Burnt Sienna
BRUSH
Medium Round Synthetic Hair
SUPPORT
Canvas Board

When acrylic is very diluted, it is similar to watercolors. The main difference is in the amount that is absorbed by the support (supports for acrylics are not very absorbent) and in the greater delicacy of the colors. Here we will use two colors to create a delicate monochrome that suggests the cold and fog among the trees.

1. Paint several tree trunks with long brushstrokes of a mixture of diluted blue and sienna. The width of the trunks is the same as the width of the brush when pressed flat against the support.

2. The different concentrations of color create a variety of textures that suggest the bark of the tree. The effect is similar to that created when painting with watercolors.

3. The branches are painted with the tip of the brush to create thin lines. When the paint makes contact with the areas that are very damp, the new colors expand and blur.

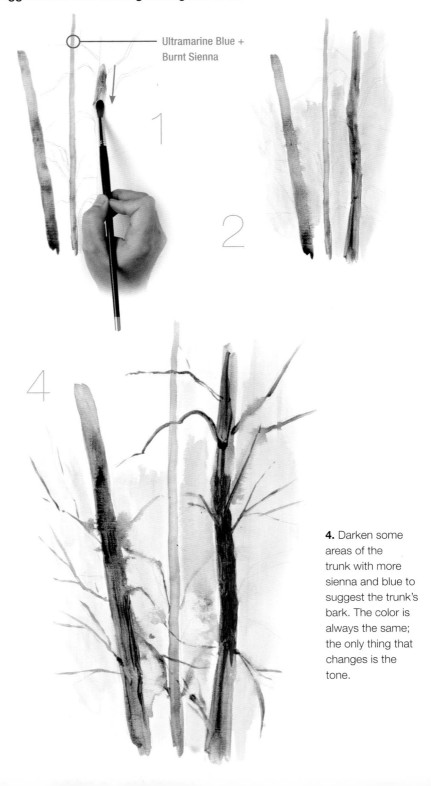

Ultramarine Blue + Burnt Sienna

4. Darken some areas of the trunk with more sienna and blue to suggest the trunk's bark. The color is always the same; the only thing that changes is the tone.

LEVEL OF DIFFICULTY
★
COLORS
Ochre
Sap Green
BRUSH
Medium Round Synthetic Hair
SUPPORT
Paper for acrylic paint

The quick drying time of acrylic paints makes it possible to paint wet over dry without much wait. In this exercise, you will paint several layers of similar colors until you create a texture that mimics the characteristics of a pear. Use just two colors, and work from light to dark.

1. Paint the body of the pears with a diluted mixture of green and ochre. The colors will be transparent.

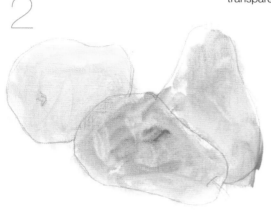

Sap Green + Ochre

2. The three pears present a light layer of very transparent color where the marks of the brushstrokes are visible.

3. When the previous layer has dried, paint additional ones over it with diluted color, changing the appearance progressively from ochre to green.

4. The last color applications, which correspond to the darker areas of the fruits, are the greenest. The accumulation of transparent layers of paint has resulted in an interesting representation of the pears' skin.

LEVEL OF DIFFICULTY
★
COLORS
Cadmium Red
Carmine
Lemon Yellow
Permanent Green
Sap Green
BRUSHES
Wide Flat Synthetic Hair
Fine Round Synthetic Hair
SUPPORT
Canvas Board

Transparencies with acrylic paints can be created through layers of diluted color or by forcing the transparency of the thick colors. In this case, we place pieces of paper over recently painted areas, which create areas of transparent color.

1. With the flat brush, paint oval areas of thick color. Do this freehand, without the aid of a preliminary drawing, just keeping in mind that these will become the petals.

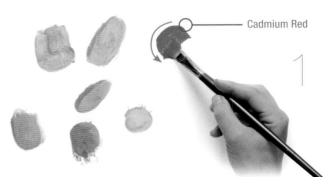

Cadmium Red

2. Place a piece of paper over the fresh paint, pressing with the hand. You can take advantage of the paint that remains on the pieces of paper and use them in a different area of the painting, pressing on the piece again.

3. You have created a series of colors over the entire support using red and carmine in different intensities depending on the pressure applied on the support with the paper. The transparency of the colors gives variety to the ensemble. Also include yellow and green areas in some parts between the petals that were left unpainted.

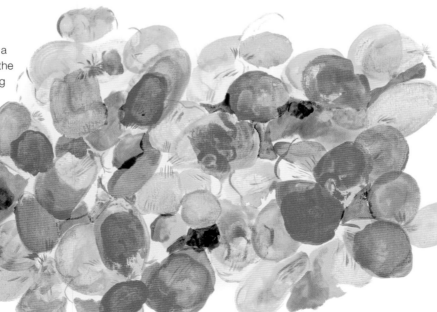

4. Add a few lines that connect the areas of color together to suggest the shapes of the flowers.

LEVEL OF DIFFICULTY
★

COLORS
Cadmium Red
Carmine
Lemon Yellow
Permanent Green
Sap Green
Ultramarine Blue

BRUSH
Medium Round Synthetic Hair

SUPPORT
Paper for acrylic paint

Combining crosshatched lines and transparencies is an interesting way of exploring the possibilities of acrylic paints. This work, which resembles an illustration, will be created by superimposing layers of crosshatched lines of different colors, resulting in a subtle and appealing and visual texture.

1. Following a simple drawing, begin by covering the body of the snake with crosshatched lines painted with the tip of the brush. Use a mixture of ultramarine blue, sap green, and cadmium red.

Ultramarine Blue
+ Sap Green
+ Cadmium Red

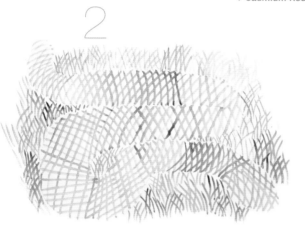

Sap Green +
Lemon Yellow

2. Complete the body with crosshatching in the shape of diamonds. The ground around the snake is done with small crosshatched lines that resemble blades of grass. The lines of diluted color blend with each other.

3. Paint the inside of the diamond shapes with sap green lightened with yellow, alternating this green with permanent green mixed with carmine, to create different tonalities.

4. When the snake is finished, add more lines for the grass, working with a mixture of yellow and red and gradually adding a small amount of permanent green.

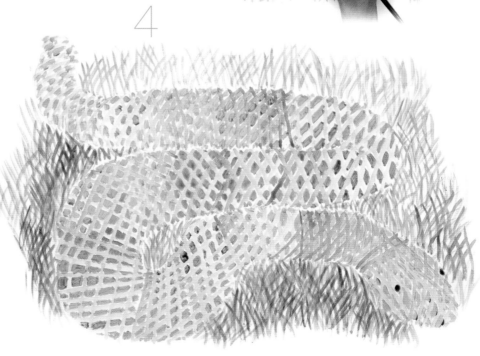

LEVEL OF DIFFICULTY

★ ★

COLORS

Permanent Red

Carmine

Lemon Yellow

Ochre

Permanent Green

Sap Green

Cobalt Blue

Ultramarine Blue

Titanium White

Ivory Black

BRUSHES

Wide Flat Synthetic Hair

Narrow Flat Hog Bristle

Medium Round Natural Hair

SUPPORT

Stretched Canvas

This exercise takes advantage of the inherent luminosity of all transparent paints, combined with bright and contrasting colors. Colorful fish are a subject matter that is very suitable for this technique for their suppleness, tonal variations, and their sharp and fluid colors.

Lemon Yellow
+ Permanent Red
+ Ochre

1. Make a light drawing of the silhouettes of several fish and begin by painting the lighter colors: the yellows lightly mixed with ochre and permanent red.

2. Continue painting the multicolor fish: working from light to dark, the red fish follow the yellow and orange fish followed by green and blue ones. Only two or three brushstrokes done with a flat synthetic brush are needed for each fish.

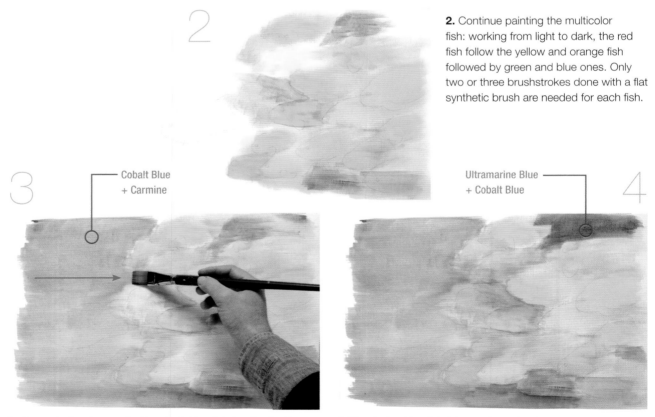

Cobalt Blue
+ Carmine

Ultramarine Blue
+ Cobalt Blue

3. Cover the background with cobalt blue lightly mixed with carmine using wide brushstrokes applied horizontally to suggest the water's movement.

4. The darker blue fish (ultramarine mixed with cobalt) are painted directly over the blue background.

5. To define the silhouette of the fish, paint their outlines with the tip of the narrow brush. Use very diluted blue and orange paint to avoid emphasizing the form too much.

White is a very opaque color that can be used to create shiny and solid highlights that give the work a feeling of firmness. In this case, we have used white brushstrokes to form the head and fins of the fish.

5

6

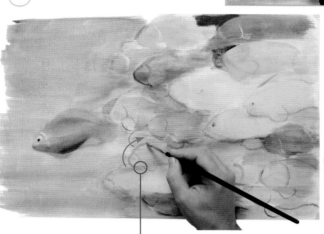

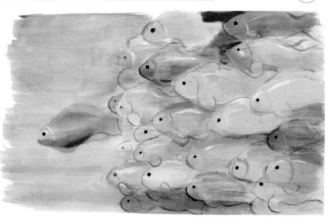

Lemon Yellow + Permanent Red

6. Paint little black dots for the eyes. This detail enhances and brightens the fish emphasizing the sense of a large grouping.

7

7. The transparent treatment creates a feeling of suppleness and enhances the movement suggested by the position and the volume of the fish.

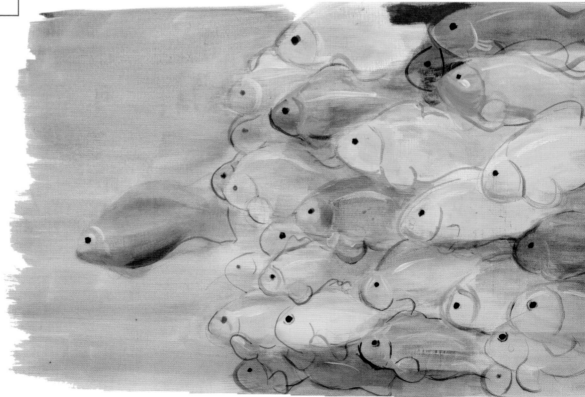

LEVEL OF DIFFICULTY

★

COLORS

Yellow Ochre

Lemon Yellow

Burnt Sienna

Sap Green

Cobalt Blue

Ivory Black

Titanium White

BRUSHES

Medium Flat Synthetic Hair

Fine Round Synthetic Hair

SUPPORT

Paper for acrylic paint

Transparent color is the most appropriate treatment for themes where the transparency of the object is emphasized. In this case, the object is a glass that contains a drink with ice cubes. The painting of the liquid, the ice, and the glass includes, but is not limited to, transparent colors.

1. In this exercise, the drawing is important because the colors must take into account the outlines of the different forms as well as the symmetry of the glass.

2. We cover the area of the liquid with ochre mixed with a touch of burnt sienna. The paint should not be too thick so it maintains a level of transparency. Leave the area of the ice cubes unpainted.

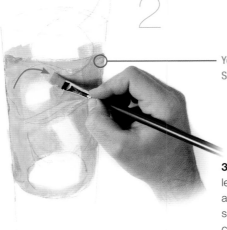

Yellow Ochre + Burnt Sienna

3. After painting the lemon with green and yellow, draw the shapes of the ice cubes with black lines of varying degrees of thickness and sinuous configuration. The lines should not completely enclose the forms.

Ivory Black

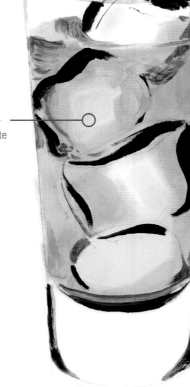

Cobalt Blue + Titanium White

4. Suggest the consistency of the ice and the glass with a small amount of blue mixed with white applied in the center of the ice cubes and the outer areas of the glass.

LEVEL OF DIFFICULTY
★

COLORS
Lemon Yellow
Permanent Red
Permanent Green
Cobalt Blue
Ivory Black
Titanium White

BRUSHES
Wide Flat Synthetic Hair
Medium Flat Synthetic Hair

SUPPORT
Paper for acrylic paint

Acrylic paints do not lose their brilliance when they are applied opaque. In the following example, a transparent background is used in combination with forms that are painted with dense colors. The background resembles the sky, which highlights the vegetables in the foreground.

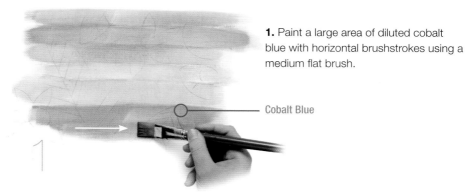

1. Paint a large area of diluted cobalt blue with horizontal brushstrokes using a medium flat brush.

Cobalt Blue

2. Paint several areas with green and yellow, which suggest the vegetation and a few leaves and flowers. The greens are made of a combination of permanent green and cobalt blue mixed in different proportions.

Lemon Yellow

Cobalt Blue + Permanent Green

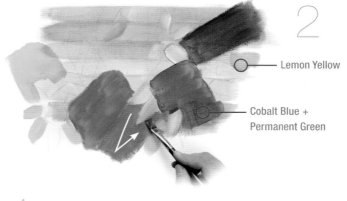

Permanent Red

3. Continue painting with more brushstrokes of saturated and opaque colors (mainly blues and reds), which appear projected forward against a transparent background.

4. Finally, draw leaves and other vegetation with a medium brush charged with black.

23

This exercise shows one of the most common ways of working with acrylic paint: first applying the colors that are diluted and transparent followed by the opaque colors. The successive layers of paint darken the surface and give solidity to the colors.

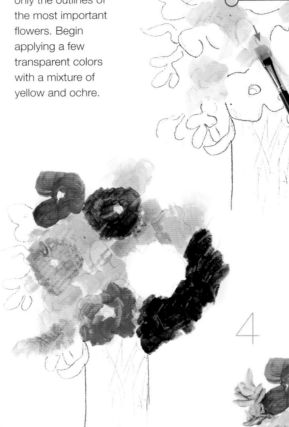

1. Make a pencil drawing of the bouquet indicating only the outlines of the most important flowers. Begin applying a few transparent colors with a mixture of yellow and ochre.

Lemon Yellow + Ochre

2. Over the previous colors paint the carmine flower and the red and violet flowers, as well as a few areas of soft violet color very diluted with water.

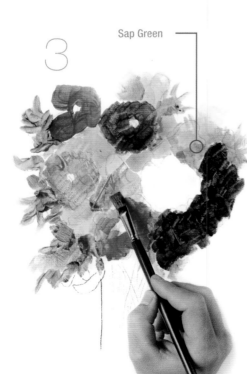

Sap Green

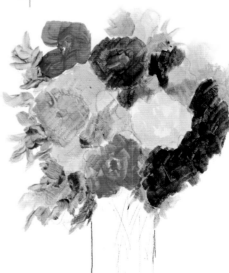

3. Apply transparent brushstrokes of sap green over the violet areas, quite diluted, allowing the color to overlap a flower here and there.

4. At this point, all the colors are transparent because they have been diluted with a considerable amount of water; the brush marks are very visible, giving the painting an impressionist look.

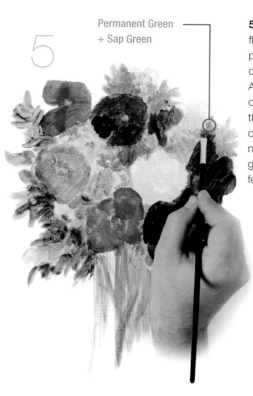

Permanent Green + Sap Green

5. The stems of the flowers have been painted with very diluted blue paint. Apply different overlapping colors that are very opaque, like the more saturated greens, to cover a few leaves.

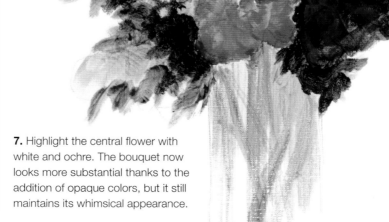

6. Touch up the flowers using the same colors, but thicker and more covering, which makes them appear more solid.

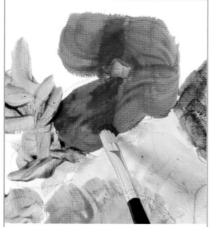

A very spontaneous approach can produce a realistic result. This can be achieved by overlapping a few opaque colors that represent the areas in the shadow or that are on a middle ground, as can be seen in this image in which carmine has been painted over a red background.

7. Highlight the central flower with white and ochre. The bouquet now looks more substantial thanks to the addition of opaque colors, but it still maintains its whimsical appearance.

LEVEL OF DIFFICULTY
★

COLORS
Sap Green
Ultramarine Blue
Burnt Sienna
Ivory Black

BRUSHES
Wide Flat Synthetic Hair
Narrow Flat Synthetic Hair

SUPPORT
Paper for acrylic paint

A good solution for compositions where you need to create a large neutral background is to apply the paint with wide semitransparent brushstrokes that spread the paint and create a texture that can be interesting for the particular subject. The theme for this exercise consists of three birds wading in the water.

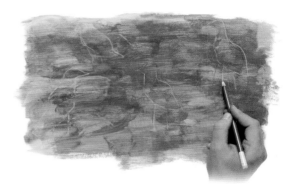

1. The background of the landscape (the shore of the sea or a river) is a vast blue area mixed with some black and green, applied very vigorously with the wide brush. Some areas are more opaque than others.

Sap Green
+ Ultramarine Blue
+ Burnt Sienna

2. Draw the silhouettes of the birds with a white pencil. The drawing should be simple and light.

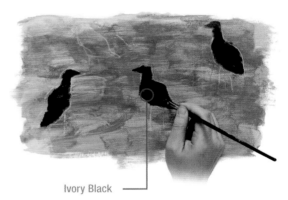

Ivory Black

3. Using the narrow brush charged with black, paint the birds. The silhouette should not be completely opaque to avoid losing the sense of volume.

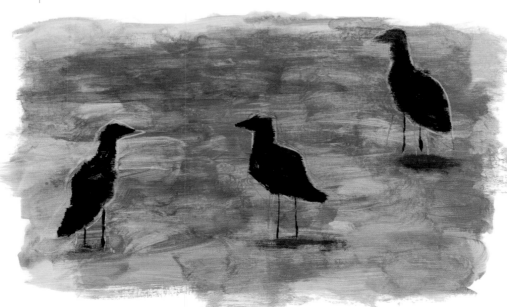

4. What is interesting in this exercise is to see how the opacity and unevenness of the paint add to the environment and charm of this scene.

LEVEL OF DIFFICULTY
★
COLORS
Lemon Yellow
Magenta
Permanent Red
Phthalo Blue
Permanent Green
Titanium White
BRUSH
Medium Flat Synthetic Hair
SUPPORT
Paper for acrylic paint

When you use very bright colors, the transparencies can be spectacular. Here we offer a very liberal representation of a type of shoe that is particularly striking. Acrylic paints are very adaptable and suitable for creating impromptu compositions.

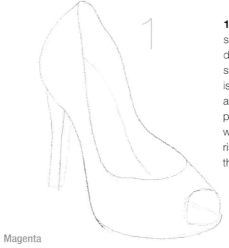

1. To make a simple and solid drawing of the subject matter, it is important to be able to apply the paint liberally and without running the risk of distorting the subject.

2. Begin with a few applications of magenta and yellow, trying to avoid touching each other to prevent the colors from becoming muddy.

Magenta

Lemon Yellow

4. Thanks to the initial drawing, we have been able to play with the colors and to achieve a very striking effect in keeping with fashion trends.

Phthalo Blue +
Titanium White

3. Add reds, oranges, and blues to the magenta and yellow. The inside of the shoe is painted with phthalo blue lightened with white and a small amount of permanent green.

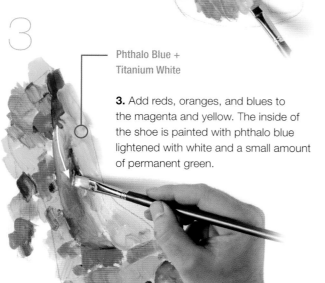

White makes colors opaque. Any transparent color becomes denser when it is mixed with white. In this example, we are going to use this quality to create a glazed effect to represent the snow and the ice on the ground of a winter landscape.

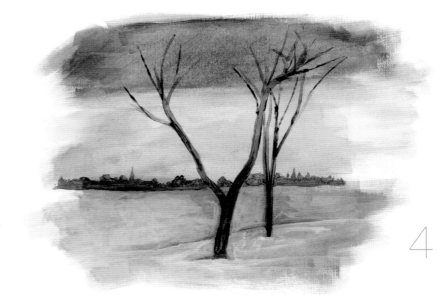

1. With the flat brush, paint the background on a three-strip configuration. The lower one is carmine mixed with a small amount of blue, considerably diluted; the middle is very light blue because we have mixed it with a large amount of white; and the upper one is blue mixed with a touch of carmine.

Phthalo Blue + Carmine

Phthalo Blue

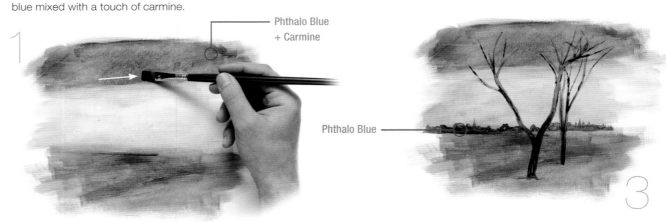

2. With the round brush charged with black somewhat diluted in water, draw the trees carefully letting the silhouette remain transparent against the color of the background.

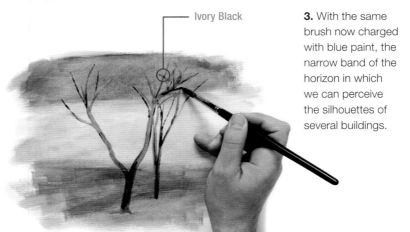

Ivory Black

3. With the same brush now charged with blue paint, the narrow band of the horizon in which we can perceive the silhouettes of several buildings.

4. Create a glazed effect on the foreground by applying white, not very thick, over it. The resulting effect is that of a coat of snow that lightly reflects the violet tone of the winter light.

LEVEL OF DIFFICULTY
★ ★

COLORS
Cobalt Blue
Yellow Ochre
Permanent Green
Titanium White
Ivory Black

BRUSHES
Wide Flat Synthetic Hair
Fine Round Synthetic Hair

SUPPORT
Stretched Canvas

In this exercise, the transparency has an impact on the theme because the bird represented here is also transparent since the color of the background emerges through it. But the result is not exaggerated, it is consistent with a procedure that is quite common, which is to separate sharply drawing from color.

1. Paint a large area of cobalt blue lightened with white over a basic drawing of the bird. Apply the color diluted with water, as needed, to allow the brush to glide easily on the support.

Cobalt Blue + Titanium White

3. The gray lines are more predominant in the rear and lower areas, which are more shaded; in those areas, the lines should be thicker. The bird's legs are painted with opaque black, and the branch and leaves are painted with ochre and green.

4. Finish the last details. The result is very fresh and lively. This technique can be used to enhance works based on drawings.

2. With the thin brush, draw the feathers with white and gray (mixture of black and white) paint.

Titanium White + Ivory Black

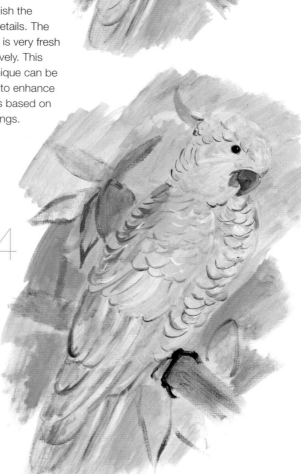

The quick drying time of acrylic paints prevents the different color layers to mix with each other, even when working fast. This means that, under normal conditions, each new color is applied over a layer that is already dry. Taking advantage of this factor, we use the very dry paint to create semitransparent color effects over opaque color.

1. Paint the shapes of the autumn treetops more or less in a triangular configuration. To do this, use a mixture of yellow and ochre, which should be spread to cover all the paper well. Once the color is completely dry, apply a small amount of red over it, not covering the color underneath.

2. Do the same with a mixture of green and red. Next, apply ochre and green mixed with red with short brushstrokes.

3. The paint is dense and covering; however, the effect achieved is not that of a solid mass but of thick foliage. We paint the tree trunks with ochre mixed with red and blue.

4. Paint the background with blue diluted with white in different proportions.

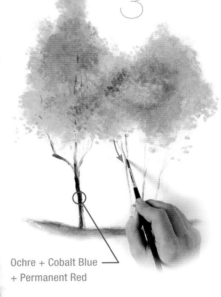

Ochre + Cobalt Blue + Permanent Red

Ultramarine Blue + Burnt Sienna

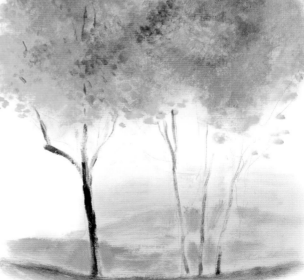

LEVEL OF DIFFICULTY
★
COLORS
Cobalt Blue
Magenta
Titanium White
Ivory Black
BRUSHES
Wide Flat Synthetic Hair
Fine Round Synthetic Hair
SUPPORT
Canvas Board

Acrylic paint, when worked with dense colors, especially if they are mixed with a small amount of white, is very opaque and covering. In this painting, we can see the contrast between a light background and an object painted with a solid color, modeled simply with its shadows and lights.

1. Draw the outline of the handbag; then cover the entire background with cobalt blue very diluted with water. Begin painting with magenta lightly mixed with white. The color is very saturated and dense.

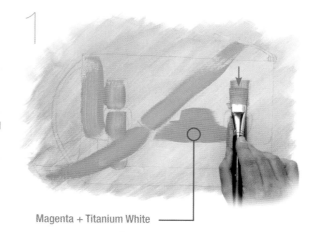

Magenta + Titanium White

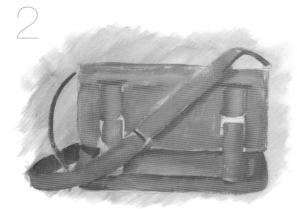

Titanium White

2. Cover the entire handbag with a pink tone, almost flat. Just darken the edges of the handbag's corners and the shadow of the strap with magenta, not lightened with white.

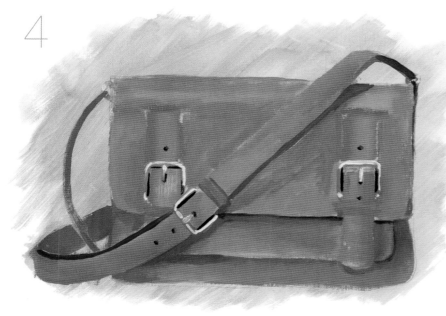

3. Use black and white for the buckles. First, paint them gray When the paint is dry, add white highlights complemented by an occasional touch of black to make them stand out more.

4. Opaque and covering colors provide a more solid and voluminous effect than transparent colors. We have achieved this volume with barely any shadows or modeling.

LEVEL OF DIFFICULTY
★

COLORS
Cobalt Blue
Yellow Ochre
Lemon Yellow
Permanent Red
Permanent Green
Titanium White
Ivory Black

BRUSHES
Medium Flat Synthetic Hair
Fine Round Synthetic Hair

SUPPORT
Canvas Board

The maximum color strength that you can obtain from acrylic paint is by using colors with high covering power, and that are saturated and thick, in other words, opaque. This exercise presents a creative representation of a rooster emphasizing the brightest color contrasts. You will use an abstract approach to make it more dynamic.

1. The initial drawing is very simple: just a few lines to outline the head, the body, and little more. Begin by densely applying yellows and blues.

2. Apply the first areas of color with diluted paint, but soon change to thick and saturated red. Paint within the previously painted lines.

Cobalt Blue

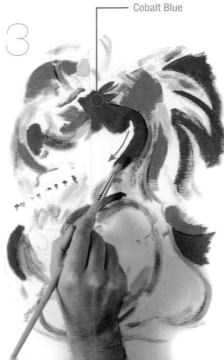

3. Now apply undiluted cobalt blue. The breaking point between the colors defines the drawing. Those borderlines must be sharp and without color blends.

Ivory Black

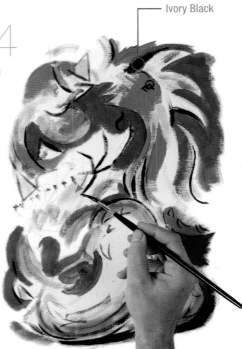

4. Use a thin brush to define a few important lines for the eye, crest, feet, and feathers. It is important not to overdue these black lines; otherwise, you will enclose the areas of color within very heavy outlines.

In this work, try to suggest the spontaneous movement of the leaping rooster. To do this, you can resort to an unusual but interesting method, which is, roll the brush charged with paint along the support to make a series of marks.

5. The blue paint should take into account the other colors, which suggest feathers or traces created by the motion of the rooster.

6. The areas of colors and the black lines provide good harmony together. Since the black lines are not continuous lines, they allow the bright colors to create the illusion of movement.

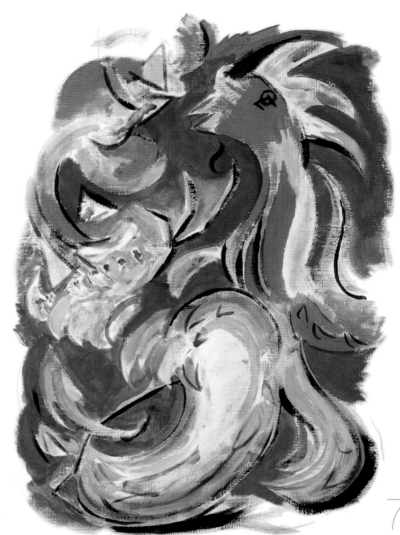

Cobalt Blue +
Titanium White

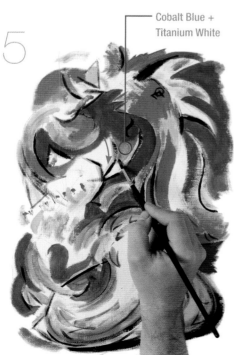

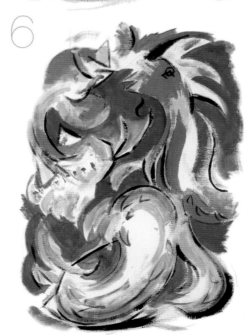

7. The opacity of the colors makes the work solid and powerful; quick transitions between one color and the next provide dynamism.

LEVEL OF DIFFICULTY
★

COLORS
Cobalt Blue
Magenta
Titanium Blue
Permanent Green
Lemon Yellow
Titanium White

BRUSH
Wide Flat Synthetic Hair

SUPPORT
Canvas Board

The opacity of acrylic colors makes it possible to work with masking tape or reserves on some areas of the support. Masking tape is adhesive tape that protects an area of the painting so that you can create sharp silhouettes or a particular color or the background color.

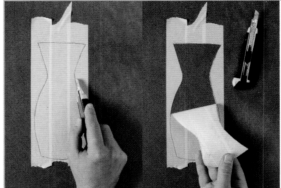

A simple way to create a stencil is to place several pieces of masking tape together one after the other and to draw the shape that you wish to cut out over them. Cut out the shape with a cutting blade, lift it from the support and adhere it to the support.

1

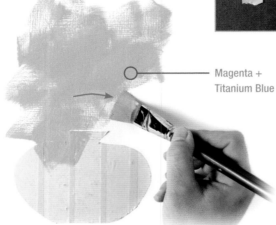

Magenta + Titanium Blue

1. Adhere the masking tape shape of the vase to the support, then paint the background with a thick and opaque mixture of magenta and titanium white.

2. When the paint is dry, place the masking tape of the vase part over the magenta background and part over the previous mask.

3. Paint the outside of the stencil with undiluted cobalt blue. The opacity of this color covers the magenta completely.

2

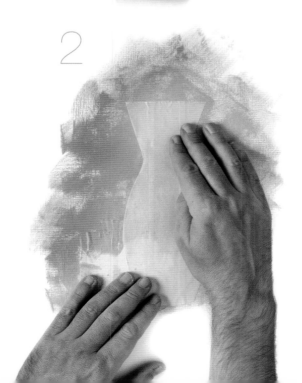

3

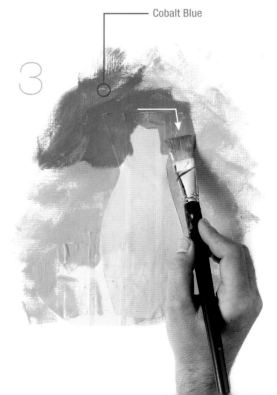

Cobalt Blue

4. Once the color is dry, peel off the masking tape in reverse order, the last one first.

5. Here is the work without the reserves: the first form has reserved the white of the support, and the second one has reserved the magenta color.

6. We only need to paint the vase that is white, using permanent green mixed with a small amount of lemon yellow.

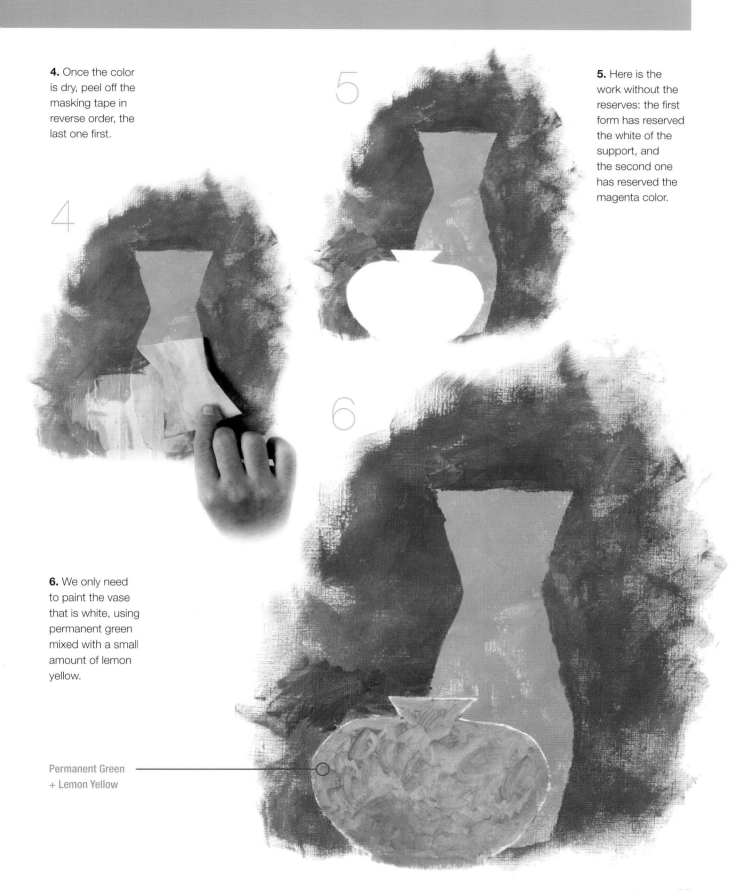

Permanent Green + Lemon Yellow

In this excercise, we place a form painted with transparent colors against an opaque background. This contrast highlights the luminosity of the form and the whimsical coloration of the animal's body. The color of the background is very opaque and darker than the colors of the salamander.

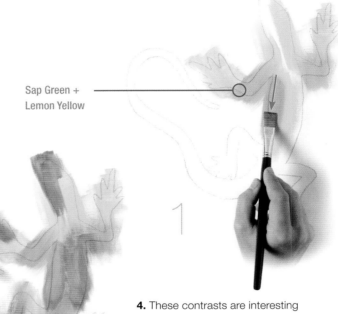

Sap Green +
Lemon Yellow

1. Paint with very transparent paints over a drawing done with a clear and well-defined outline: the color should be diluted, and the brush should not be overly charged with paint.

2. Cover the body of the reptile with pink, green (a mixture of yellow and permanent green), and red. Make an effort not to overwhelm the support with paint; the layer should be very thin.

3. Paint the outside of the salamander with sap green mixed with burnt sienna. The paint's opacity enhances the luminosity of its body even more.

4. These contrasts are interesting when the aim is to apply bright highlights or light and ethereal forms: paint the form with transparent colors and the background with opaque colors.

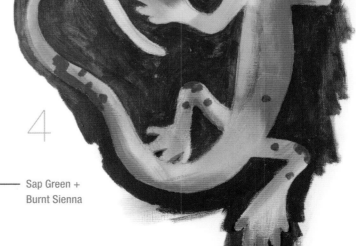

Sap Green +
Burnt Sienna

LEVEL OF DIFFICULTY
★ ★
COLORS
Lemon Yellow
Sap Green
Cobalt Blue
Ivory Black
Titanium White
BRUSHES
Thin Round Synthetic Hair
Narrow Flat Hog Bristle
SUPPORT
Stretched Canvas

This exercise outlines the conventional process of a painting. The aim is to progress from a transparent consistency to an opaque finish. At the beginning, we use colors that are very diluted with water, almost with monochromatic neutral tones. In the end, the surfaces become more solid and covering.

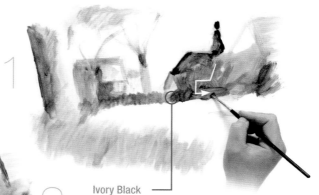

Ivory Black
+ Sap Green

1. Begin by doing a preliminary painting of the landscape, without a drawing, using a mixture of black and sap green, very diluted with water.

Sap Green +
Lemon Yellow

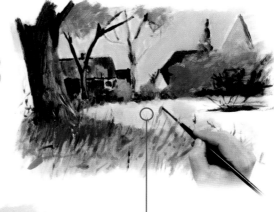

2. Highlight the use of color on the foreground by applying a thicker and covering layer of a mixture of green and yellow. Also paint the tree trunk with more saturated black, mixed with white in the more illuminated areas.

Sap Green +
Titanium White

3. Paint the sky with cobalt blue lightened with white and the green areas with opaque paint. The foreground is enhanced by covering it with details of leaves, branches, grass, and the like.

4. A few transparent color brushstrokes can still be seen underneath the areas of opaque paint. It is important to preserve that effect for the painting to keep its light appearance.

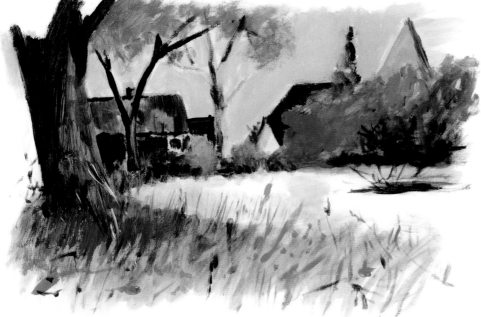

LEVEL OF DIFFICULTY
★
COLORS
Ochre
Lemon Yellow
Burnt Sienna
Sap Green
Ultramarine Blue
Titanium White
BRUSHES
Medium Flat Synthetic Hair
Thin Medium Hog Bristle
SUPPORT
Paper for acrylic paint

There are many intermediate levels of saturation between total transparency and maximum opacity. In this painting, you will see that the brushstrokes of dark color can still be slightly transparent, and this factor can add interest to the finished painting.

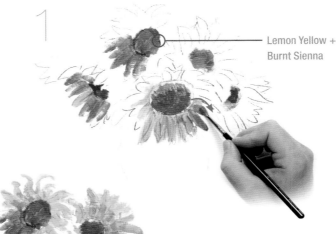

Lemon Yellow + Burnt Sienna

1. With a mixture of yellow and burnt sienna, paint the flowers on a very basic preliminary drawing. The thick paint creates areas of heavy paint, and opaque color can be seen between those areas, which enhances the organic texture of the theme.

2. The yellow and sienna mixture should be uneven with more sienna in the centers and less luminous petals of the flowers and more yellow on the most illuminated petals.

4. Apply a few brushstrokes of transparent green (lighter and more "vegetable" like than opaque green), adding thicker paint to the insides of the sunflowers until they are completely opaque.

3. Paint the vase with a mixture of blue and white: the color should be light, but darker in the least illuminated areas.

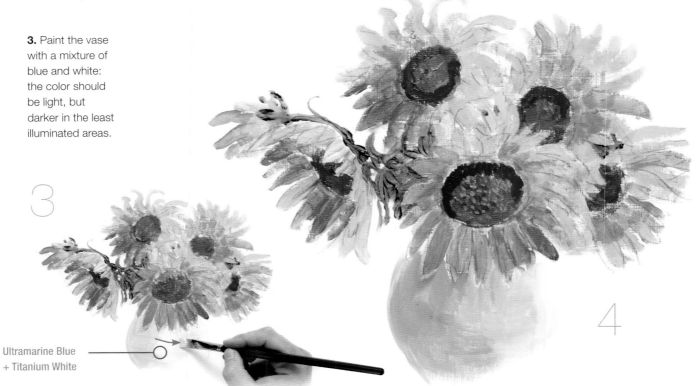

Ultramarine Blue + Titanium White

LEVEL OF DIFFICULTY
★

COLORS
Ultramarine Blue
Permanent Green
Titanium White
Ivory Black

BRUSHES
Medium Flat Synthetic Hair
Thin Round Synthetic Hair

SUPPORT
Canvas Board

The dry brush technique consists of working with undiluted paint. It is important to use a brush with a light charge of paint so it does not cover the canvas and allows the texture to be visible. To enhance this effect, you will surround the subject with completely opaque paint at the end of the process.

1. This is the drawing of the small bird that you are going to paint. It is important to choose the correct brush for this technique: it should be neither too thick nor too big. Ideally, its width should be a third of the bird's total width.

Ultramarine Blue + Permanent Green

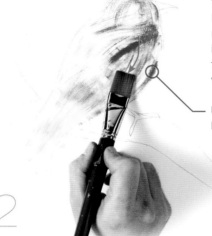

2. Since you are using a small amount of undiluted paint, traces of the brush can be seen perfectly, which creates a textured effect that mimics the feathers of the bird as well as its body.

Ultramarine Blue

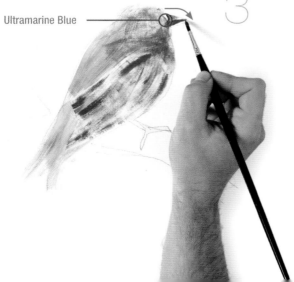

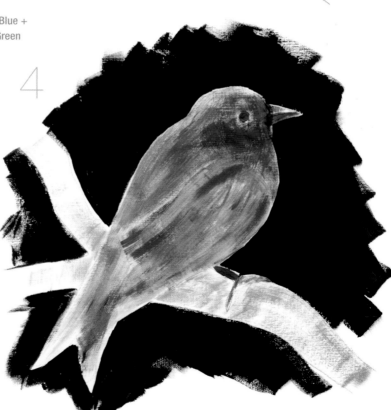

3. After you paint the entire bird, apply the smallest details with a thin brush.

4. Paint the background with black to enhance the dry brush effect.

LEVEL OF DIFFICULTY

★

COLORS

Cobalt Blue

Ultramarine Blue

Lemon Yellow

Permanent Red

Carmine

Permanent Green

Titanium White

BRUSH

Thin Round Bristle Brush

SUPPORT

Stretched Canvas

There is nothing more transparent than the atmosphere of a landscape; however, this can be achieved in a painting by using opaque colors. In this exercise, you are going to use such colors to suggest the changing light of the day and its effect on the tree branches in autumn. The colors will be treated with an impressionistic and lively approach.

1. Do a detailed drawing of the subject because the branches are very intricate and you do not want to paint them freehand. Begin painting the trunk with permanent red.

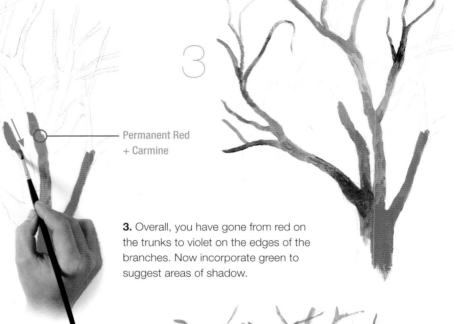

Permanent Red
+ Carmine

2. Go from one color to the next gradually by mixing red with carmine, and then darken the tone with ultramarine blue to transition from bright red to violet.

3. Overall, you have gone from red on the trunks to violet on the edges of the branches. Now incorporate green to suggest areas of shadow.

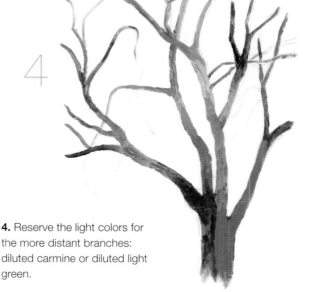

Permanent Red
+ Carmine
+ Ultramarine Blue

4. Reserve the light colors for the more distant branches: diluted carmine or diluted light green.

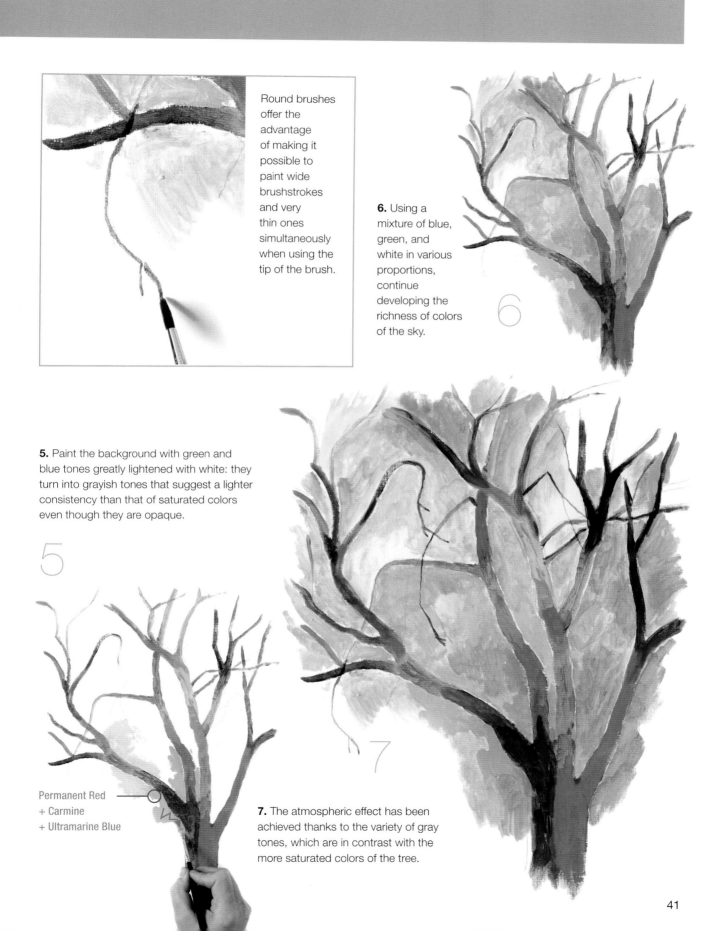

Round brushes offer the advantage of making it possible to paint wide brushstrokes and very thin ones simultaneously when using the tip of the brush.

6. Using a mixture of blue, green, and white in various proportions, continue developing the richness of colors of the sky.

5. Paint the background with green and blue tones greatly lightened with white: they turn into grayish tones that suggest a lighter consistency than that of saturated colors even though they are opaque.

Permanent Red
+ Carmine
+ Ultramarine Blue

7. The atmospheric effect has been achieved thanks to the variety of gray tones, which are in contrast with the more saturated colors of the tree.

Acrylic paints are very easy to apply, which makes it possible to paint thick layers and superimpose areas of color. There is no worry about colors getting muddied because the paint dries fast and new color can be painted over it. The brushstrokes in this case are like pieces of a puzzle made of similar colors.

1. Draw a seascape with a high horizon line so that the beach will occupy most of the composition in the foreground. The beach has a very diluted ochre coloration mixed with a small amount of sienna. Immediately apply short, horizontal, and thick brushstrokes of that same color as well as yellow mixed with white.

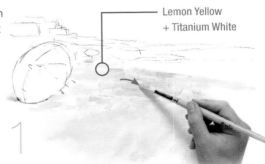

Lemon Yellow
+ Titanium White

1

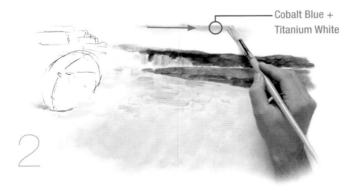

Cobalt Blue +
Titanium White

2

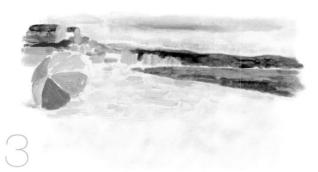

3

2. Continue painting parts of the sea, the horizon, and the sky with the round brush. Use pure blue cobalt mixed with a small amount of white for the sea and cobalt blue mixed with permanent green for the horizon. Use yellows and ochres for the buildings.

3. For the buildings and the beach umbrella in the middle ground, use a variety of colors: permanent red, blue, greenish blue, and gray made of a mixture of all these colors with white. For the umbrella use pure colors (yellow, green, red, and mauve) mixed with white. The mauve color is the result of mixing blue and red with white.

4. Now we only need to paint the foreground with short horizontal brushstrokes and thick paint. Use ochre and mauve colors mixed with white to cover the foreground with a "pebble" like consistency that evokes the texture of the sand on the beach.

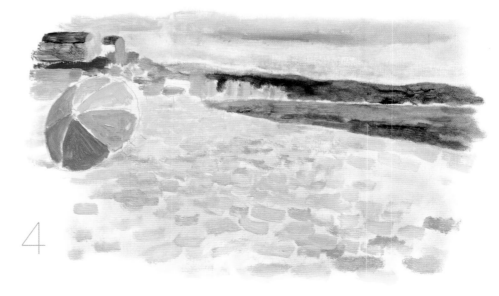

4

COLORS
Lemon Yellow
Yellow Ochre
Permanent Red
Sap Green
Titanium White
BRUSH
Wide Flat Synthetic Hair
SUPPORT
Paper for acrylic paint

When you drag a brush charged with paint that has not been greatly diluted, you can obtain interesting color and texture effects resulting from the partial or incomplete mixture of colors. In this exercise, you are going to use a few colors with very little blending, simply superimposed over each other through dragging and "broken" strokes.

1. The pencil drawing of this grasshopper is simply a matter of marking its outline.

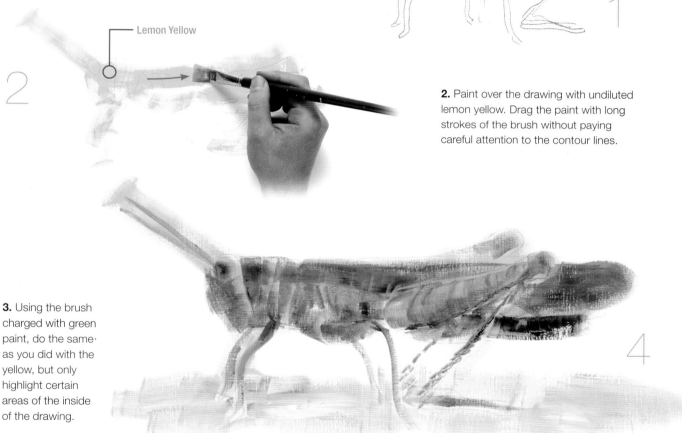

2. Paint over the drawing with undiluted lemon yellow. Drag the paint with long strokes of the brush without paying careful attention to the contour lines.

3. Using the brush charged with green paint, do the same· as you did with the yellow, but only highlight certain areas of the inside of the drawing.

4. Add ochre over the green following the same procedure. Finally, paint the ground with a mixture of red and white.

Lemon Yellow

Sap Green

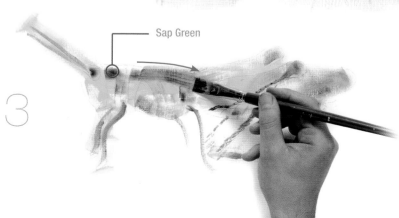

LEVEL OF DIFFICULTY
★
COLORS
Burnt Umber
Sap Green
Permanent Red
Carmine
BRUSHES
Narrow Flat Synthetic Hair
Thin Round Hog Bristle
SUPPORT
Paper for acrylic paint

Unless you apply the paint thickly, acrylics are quite transparent when diluted with water. This transparency varies according to the amount of paint applied giving the colors an irregular appearance. In this exercise, you will take advantage of this property to achieve a realistic effect by playing with the consistency of the brushstrokes.

Sap Green

1. Do a pencil drawing to outline the figure, after which we paint the first leaves with the flat veins of the leaf.

2. To paint the branch, we charge the round brush with burnt umber. This time the brush marks will represent the knots of the branch.

Carmine

Permanent Red

3. The cherries are painted with diluted red, except the two on the left, which are painted with carmine. When we paint them, we leave a small area unpainted to suggest the shininess of the fruit.

4. Add a couple more leaves to the small cherry branch to finish the exercise.

LEVEL OF DIFFICULTY
★ ★

COLORS
Cobalt Blue
Yellow Ochre
Burnt Sienna
Permanent Red
Carmine
Permanent Green
Titanium White
Ivory Black

BRUSHES
Narrow Flat Synthetic Hair
Thin Round Synthetic Hair

SUPPORT
Canvas Board

This type of seemingly incoherent and disorganized brushstroke is used to create a spontaneous and surprising effect. The brushstrokes are applied spontaneously and in large formats with no apparent relationship to the outlines of the theme. The secret lies in the variety of the color contrasts, the size of the areas of colors, and the direction of the brushstrokes.

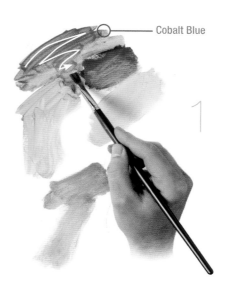

Cobalt Blue

1. Extend the first areas of color, which contrast with each other: ochre, blue, and burnt sienna, all diluted.

2. Group together a series of color blocks that conform more or less to the configuration of a face. Paint it with thicker blue, violet blue mixed with carmine, turquoise blue (blue and green mixed together), and black.

3. Paint the facial features over the blocks of color with the tip of the brush using black.

Ivory Black

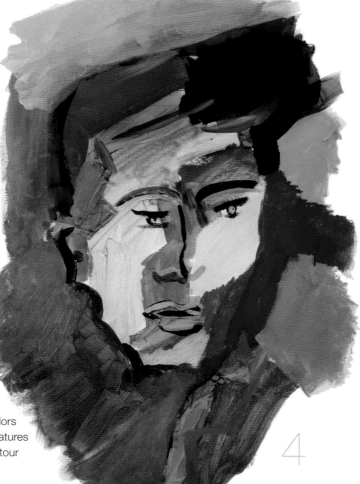

4. Use contrasting colors based on the facial features to emphasize the contour of the face.

LEVEL OF DIFFICULTY
★ ★

COLORS
Cobalt Blue
Ultramarine Blue
Yellow Ochre
Permanent Red
Sap Green
Titanium White
Ivory Black

BRUSHES
Narrow Flat Hog Bristle
Medium Flat Synthetic Hair

SUPPORT
Stretched Canvas

"Divisionism" is a style consisting of fragmented brushstrokes that aim at separating the colors into individual (or divided) areas that make up a chromatic mosaic of brilliant colors. This mosaic is made up of dots or areas of color that greatly resemble each other in size and shape resulting in a coherent chromatic ensemble.

Cobalt Blue + Titanium White

1. After blocking in part of the scene in which are included the tree trunks and the bottom edge of the field, paint the sky with a mixture of cobalt blue and white. In this area, the brushstrokes are partially blended together.

2. Paint a few leaves with the same blue color, and add big areas of sap green grouped together around the branches.

Cobalt Blue

3. The middle ground consists of a mosaic of colors by alternating ochre, green lightened with white, and a mixture of these three colors. Apply the brushstrokes horizontally.

4. The background behind the trees is a mixture of ultramarine blue, black, and an occasional touch of green.

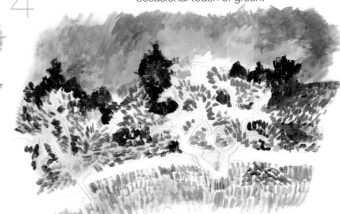

5. To define the tree trunks use diluted and evenly blended red. You only need to outline the contours with a line as thick as the hair of the brush.

6. Begin to paint the stone wall of the middle ground with cool tones, which is the result of mixing ultramarine blue, white, and a touch of red.

Permanent Red

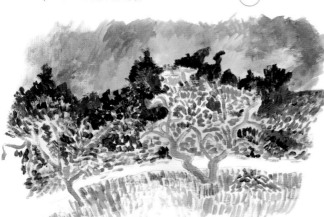

7. The final result is luminous (thanks to the areas left unpainted) and has great chromatic power.

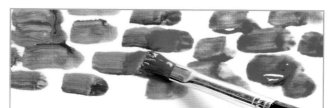

The transition between colors in a mosaic of divided brushstrokes is achieved by incorporating intermediate tones, a result of the mixture with nearby colors.

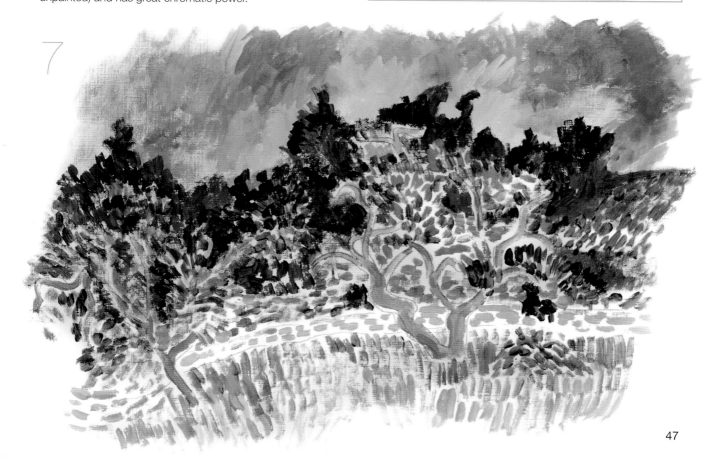

LEVEL OF DIFFICULTY
★
COLORS
Ochre
Cadmium Yellow
Sap Green
Permanent Green
BRUSH
Thin Round Synthetic Hair
SUPPORT
Paper for acrylic paint

This exercise, which is very simple, consists of painting a flower with informal brushstrokes that are not well defined. The color of the background (applied first) plays an important role since the brushstrokes of the flower blend with it partially, creating a soft and atmospheric effect.

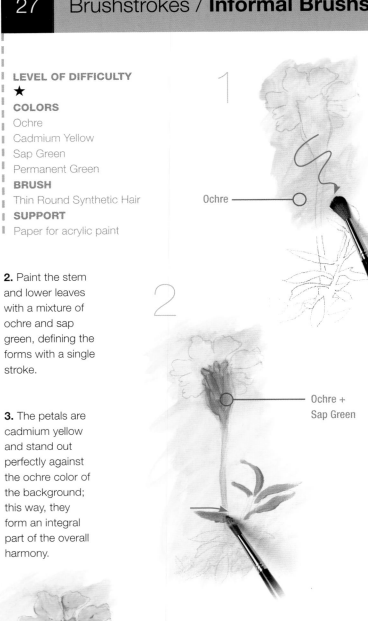

1

Ochre

2

Ochre + Sap Green

3

4

1. Over a simple pencil drawing, paint an area with diluted ochre color using light brushstrokes without much definition.

2. Paint the stem and lower leaves with a mixture of ochre and sap green, defining the forms with a single stroke.

3. The petals are cadmium yellow and stand out perfectly against the ochre color of the background; this way, they form an integral part of the overall harmony.

4. The resulting effect is soft, characterized by brushstrokes that are not very defined and that blend well with the overall tone and texture.

LEVEL OF DIFFICULTY

★

COLORS

Ultramarine Blue
Cobalt Violet
Cadmium Yellow
Permanent Red
Carmine
Permanent Green
Sap Green
Titanium White
Ivory Black

BRUSH

Thin Round Synthetic Hair

SUPPORT

Canvas Board

The style of brushstroke used in this exercise is unusual, but it offers many decorative possibilities, especially for large formats. You will use the dense colors of the subject matter to develop sinuous and wavy brushstrokes.

1. To avoid conditioning the development of the brushstrokes, do not create a preliminary drawing. The first brushstrokes should be violet combined with a small amount of blue and carmine. Add a few strokes of permanent green and sap green to the top of the tree.

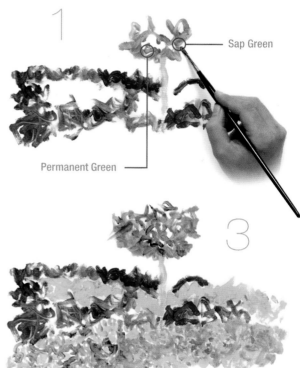

Sap Green

Permanent Green

2. Distribute multiple yellow dots of thick paint among the areas of violet color.

3. Between the yellow dots add areas of color similar to the first ones with permanent green mixed with a small amount of sap green. Also, combine both colors on the top of the tree.

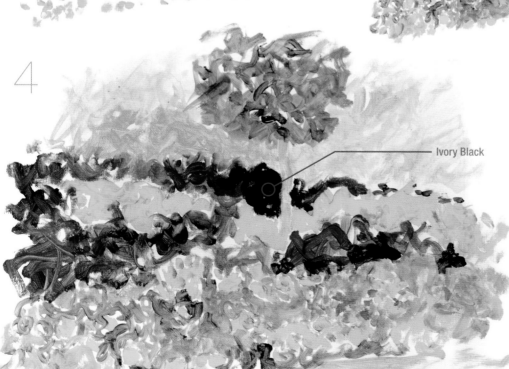

Ivory Black

4. Intensify the dotted effect on the flowers as well as in the darker areas (which you have covered with black). The sky is painted with sinuous brushstrokes using a mixture of blue and white.

LEVEL OF DIFFICULTY

★

COLORS

Cobalt Blue

Cadmium Yellow

Permanent Red

Magenta

Permanent Green

Sap Green

Titanium White

BRUSH

Thin Round Synthetic Hair

SUPPORT

Stretched Canvas

Whenever you paint with broken brushstrokes, the results will be luminous and very colorful. Below, we will show you how to work with elongated hatched brushstrokes, in such a way that the form is created by changing the direction of the strokes.

1. It is important to create a clear initial drawing to outline the different hatched pencil lines.

2. First, paint the insides of the flowers with thin lines; use yellow on the corolla and magenta for the petals. Cover the flowers located farther away with hatch marks of blue lightly mixed with the magenta.

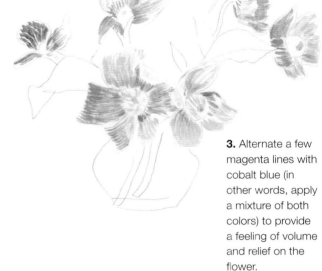

3. Alternate a few magenta lines with cobalt blue (in other words, apply a mixture of both colors) to provide a feeling of volume and relief on the flower.

4. Paint the leaves with sap green and permanent green, using thin brushstrokes as well.

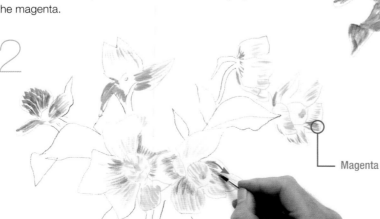

Magenta

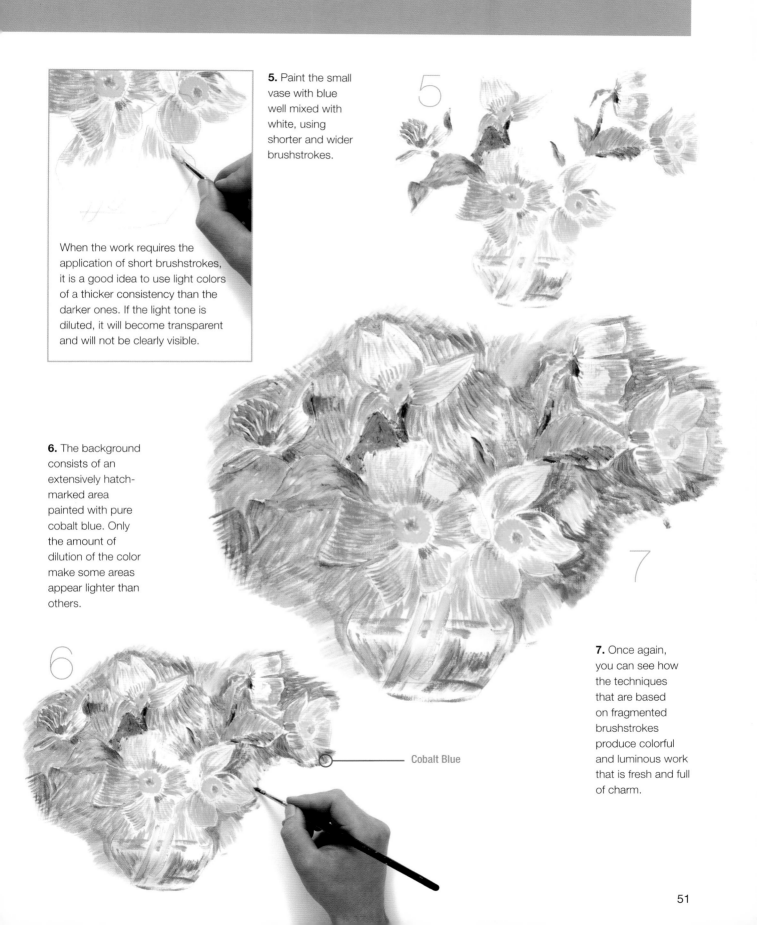

5. Paint the small vase with blue well mixed with white, using shorter and wider brushstrokes.

When the work requires the application of short brushstrokes, it is a good idea to use light colors of a thicker consistency than the darker ones. If the light tone is diluted, it will become transparent and will not be clearly visible.

6. The background consists of an extensively hatch-marked area painted with pure cobalt blue. Only the amount of dilution of the color make some areas appear lighter than others.

Cobalt Blue

7. Once again, you can see how the techniques that are based on fragmented brushstrokes produce colorful and luminous work that is fresh and full of charm.

LEVEL OF DIFFICULTY
★
COLORS
Ultramarine Blue
Lemon Yellow
Permanent Red
Magenta
Permanent Green
BRUSH
Medium Flat Synthetic Hair
SUPPORT
Paper for acrylic paint

With certain subjects, you can define a form directly by using brush marks rather than having to draw it first. This becomes a simple and elegant approach when the shapes of the brushstrokes coincide with those of the objects. The tulips in this exercise, with their vibrant and saturated color, are a good example of this technique.

3. Add more leaves and also the stems with continuous brushstrokes of permanent green in which you should add yellow to a greater or lesser degree.

1. Add a few yellow brushstrokes, which immediately give shape to the flower's yellow petals. Then add a few areas of red, and paint magenta over them.

— Permanent Red

4. Finally darken some of the stems and leaves to give depth to the piece.

2. Create a few blue petals mixed with magenta, and then paint the leaves with long brushstrokes of green mixed with very diluted yellow.

— Lemon Yellow +
Permanent Green

LEVEL OF DIFFICULTY
★ ★

COLORS
Ochre
Burnt Sienna
Titanium White
Ivory Black

BRUSHES
Medium Round Hog Bristle
Thin Round Synthetic Hair

SUPPORT
Paper for acrylic paint

The most common approach is to use brushstrokes of different sizes, shapes, and directions. The contrast between these factors is part of the expressivity of the work. Here, you will work with contrasting brushstrokes; each style responds to a particular need.

1. The goal of the pencil drawing is to establish the proportions of the squirrel's body to make it look believable.

2. Paint the body with very diluted ochre. Add a few brushstrokes of light gray around the paws and the head. This gray suggests the shadows as well as the color changes in the fur.

3. After painting the background with light diagonal brushstrokes of diluted sienna, paint the squirrel's back with short brushstrokes of ochre to define the shape and the volume of the body.

Titanium White
+ Ivory Black

4. Finally, darken all the colors, without making substantial changes. For the background, use energetic brushstrokes of thick burnt sienna, while finishing the fur of the animal with more small touches of color.

Ochre

LEVEL OF DIFFICULTY

★ ★

COLORS

Ultramarine Blue

Lemon Yellow

Permanent Red

Sap Green

Titanium White

Ivory Black

BRUSHES

Large Round Hog Bristle

Thin Round Synthetic Hair

Wide Flat Synthetic Hair

SUPPORT

Stretched Canvas

In this exercise we abandon the proper brushstroke in favor of pure blocks of color, splashes, drips, and the like. It is a completely spontaneous approach; however, that does not mean there is no goal or plan in mind. The subject is still represented in a very convincing way.

3. The central large spot of paint stands out against the background, which goes well with the overall spontaneous approach of the painting.

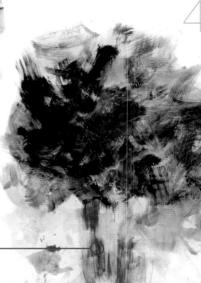

Ultramarine Blue

1. Create a base of soft blotches of color, considerably diluted in water (use blue, red, and black). It should give the impression of being spontaneous and chaotic.

2. Using a flat brush with a mixture of green, black, and yellow, proceed with vigorous brushstrokes and without hesitation. Charge the brush with abundant paint and move it in all directions.

4. Continue using the flat brush, painting with thick vertical brushstrokes of diluted blue to insinuate the shape of a vase.

Sap Green +
Lemon Yellow +
Ivory Black

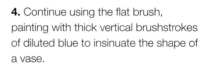

5. With the large round brush charged with white, paint a few flowers over the green mass of color. The flowers consist simply of three or four blotches of white color without any details.

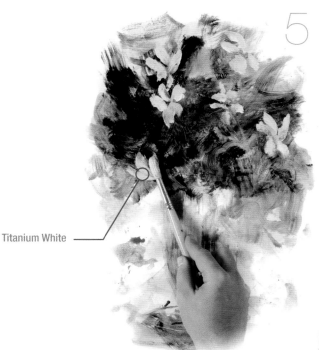

Titanium White

Use heavily diluted paint and alternate brushstrokes, tapping the brush on the support to vary the effect and achieve a spontaneous look.

6. To emphasize the forms, we add with the thin brush a few green touches in the shape of dots, on the lower area of the large mass of color.

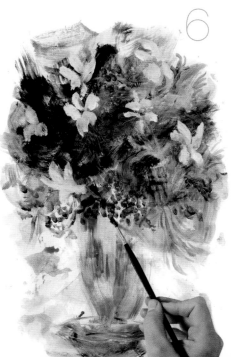

7. This painting style, which is so spontaneous and seemingly unrefined, produces unexpectedly convincing and very interesting plastic results.

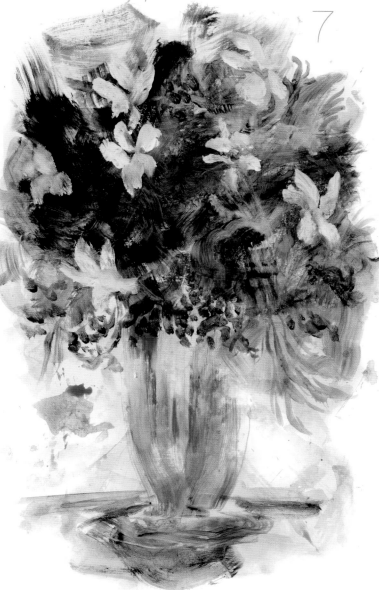

LEVEL OF DIFFICULTY

★

COLORS

Ultramarine Blue
Lemon Yellow
Permanent Red
Permanent Green
Sap Green
Titanium White
Ivory Black

BRUSH

Fine Round Synthetic Hair

SUPPORT

Canvas Board

Generally speaking, cool colors are those that gravitate toward blue and green tones. This exercise consists of creating harmony with those tones in their purest and most saturated forms, in other words, with hardly any blending between colors.

1. A simple but very precise drawing in terms of the outlines gives way to a methodical display of color created by filling in the areas with a mixture of sap green and permanent green.

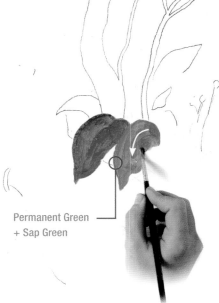

Permanent Green + Sap Green

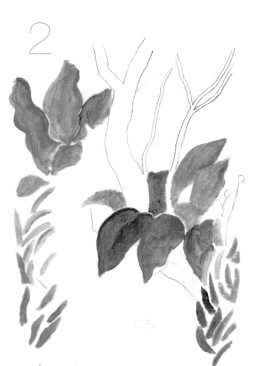

2. Continue painting all the green areas systematically, combining two greens with an occasional addition of yellow to create the lighter nuances.

3. Now paint the pond water with ultramarine blue and just the right dilution of water to make the brush glide easily.

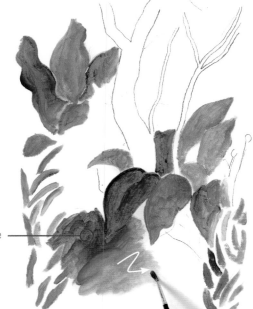

Ivory Black

4. After painting the tree trunk with the same blue used for the water, quickly apply black mixed with a small amount of blue on the opposite side of the drawing before it dries.

Ultramarine Blue

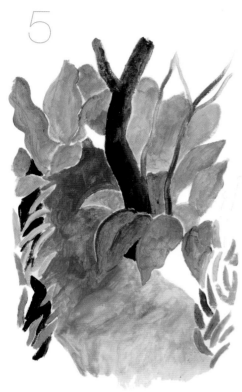

5. The trunk is now well modeled. The different shades of green blended on each leaf create the feeling of volume.

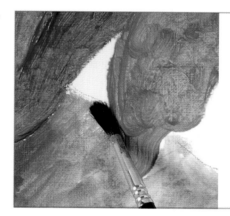

When touching up the outlines of the forms and painted areas, it is a good idea to do it with the brush held sideways, that way its straight side will draw a sharp edge.

6. Now continue painting small yellow and red details, without mixing them, to suggest the flowers and to introduce a warm chromatic contrast.

7. The feeling of coolness and shade has been achieved with basic color techniques, similar to Naïve paintings.

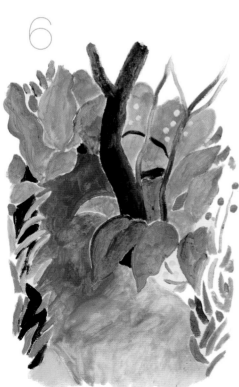

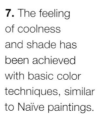

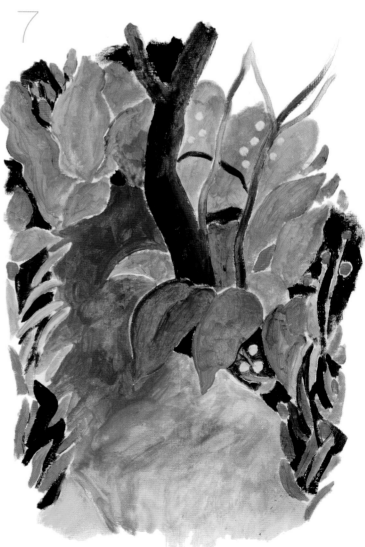

LEVEL OF DIFFICULTY
★
COLORS
Burnt Sienna
Burnt Umber
Ochre
BRUSHES
Flat Medium Synthetic Hair
Round Medium Synthetic Hair
SUPPORT
Canvas Board

All warm colors are related to red and orange. This includes the saturated yellows as well as the earth tones. This exercise is based on earth tones, specifically ochre and burnt sienna. A harmony of chestnut colors is typical of autumn themes.

Burnt Sienna
+ Ochre

1. Paint a large area of the preliminary drawing with very diluted sienna mixed with ochre. Scrub it vigorously until the brush marks are no longer visible.

2. Paint the leaves with burnt sienna. The brush marks left by the edge of the flat brush are important because they help create the typical texture of the dry leaf.

Burnt Umber

3. Paint the lighter leaves with ochre and the darker ones with burnt umber. Use the round brush, which has a good point, to draw the small branches with sienna.

4. The result is a harmony of warm colors, typical of an autumn theme.

LEVEL OF DIFFICULTY
★

COLORS
Ochre
Lemon Yellow
Sap Green
Cobalt Blue
Ivory Black
Titanium White

BRUSHES
Medium Flat Synthetic Hair
Medium Round Synthetic Hair

SUPPORT
Stretched Canvas

This exercise includes a range of warm, soft colors. A cool dark color, blue, is introduced into the composition to make the painting livelier. Despite the concern for harmony, it is important to break the overall chromatic tendency with a color from a completely different range.

1. Go over the lines with black to emphasize the few that should be clearly visible.

2. Fill all the spaces with a soft tone made with a mixture of ochre and white.

Ochre +
Titanium White

3. Paint the lemons yellow, which fits very well within the dominant color range. Leave the plant unpainted and cover the sky with thick, pure cobalt blue. When this is dry, draw black lines to suggest tree branches.

Ivory Black

4. As you can see, the pure blue enlivens and brightens the very warm tones. In addition, it introduces the feeling of space by bringing the objects closer to the foreground.

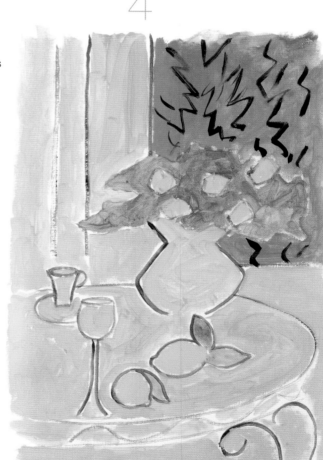

LEVEL OF DIFFICULTY

★

COLORS

Permanent Red

Cadmium Yellow

Carmine

Ultramarine Blue

Cobalt Blue

Sap Green

Titanium White

BRUSHES

Large Round Hog Bristle

Medium Round Synthetic Hair

SUPPORT

Canvas Board

Complementary colors are the pairs of colors consisting of red and green, violet and yellow, and orange and blue. They represent the greatest contrast possible. In this exercise, all the colors stem from these color opposites.

Cobalt Blue
+ Ultramarine Blue
+ Carmine

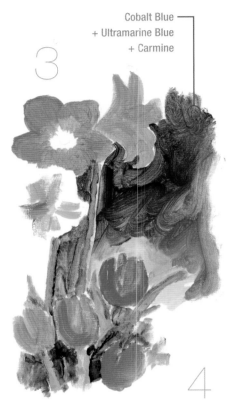

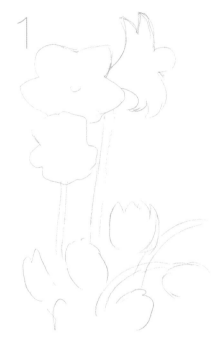

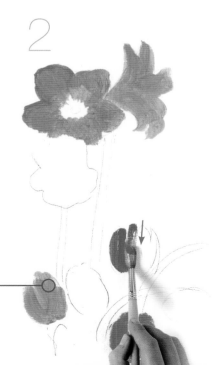

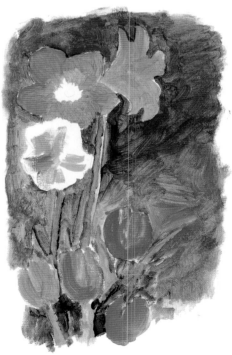

1. The pencil drawing defines the parts of the composition that will constitute the main areas of color.

2. Paint the flowers with red mixed with yellow. The mixture is not homogenous; in certain areas the reds have an orange undertone.

3. Paint the stems with green, followed by the background, which should be covered with a mixture of cobalt blue, ultramarine, and a small amount of carmine, which will make the blue turn violet in certain areas.

4. Color the flower, which was left unpainted, with quick brushstrokes of carmine. The blue should surround the flowers in their entirety to create a striking chromatic effect.

Permanent Red
+ Cadmium Yellow

5

Permanent Red + Carmine

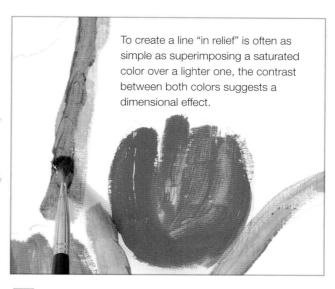

To create a line "in relief" is often as simple as superimposing a saturated color over a lighter one, the contrast between both colors suggests a dimensional effect.

6

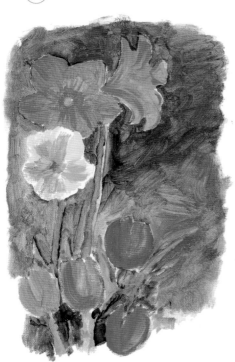

7

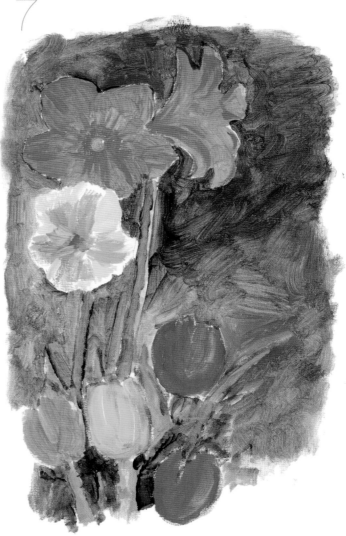

5. Apply a more saturated red in the center of the flower to intensify the dark color.

6. Because of the contrast, the bright flowers stand out, and even have a three-dimensional effect.

7. To highlight the contrast between complementary colors even more, paint the tulip yellow. This is the complement of violet, which is dominant in various areas of the background.

LEVEL OF DIFFICULTY

★

COLORS

Cadmium Yellow

Sap Green

Burnt Sienna

BRUSHES

Medium Round Synthetic Hair

Thin Round Synthetic Hair

SUPPORT

Paper for acrylic paint

Value refers to the intensity of the colors. Two different colors can have similar intensities (or values). Normally, the intensity or value of a color is related to its amount of saturation. This example creates a harmony using colors with a low saturation, and therefore light values or intensities.

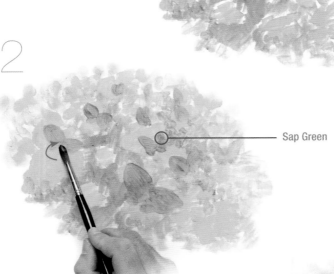

1. In a preliminary drawing, paint several yellow and green areas of different sizes. The green, quite diluted, surrounds the yellow areas.

2. Paint silhouettes with very diluted (transparent) green over the previously painted areas when they are completely dry. They are the silhouettes for butterfly wings.

3. Use the thin brush to paint the bodies of the butterflies with simple lines of burnt umber.

4. The slightly saturated colors cause the forms to visually blend with the background. The differences in the sizes of the butterflies create a feeling of depth.

Sap Green

Burnt Sienna

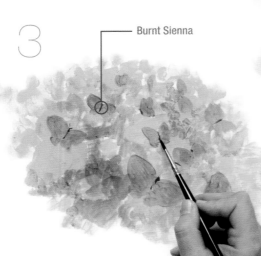

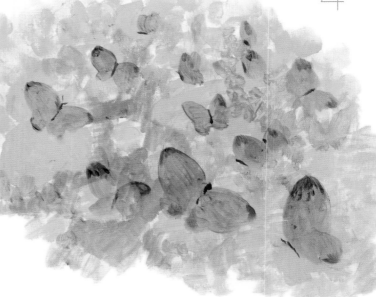

LEVEL OF DIFFICULTY
★
COLORS
Cadmium Yellow
Burnt Sienna
Phthalo Blue
Ivory Black
Titanium White
BRUSHES
Medium Flat Synthetic Hair
Thin Round Synthetic Hair
SUPPORT
Canvas Board

Cadmium Yellow + Burnt Sienna

Ivory Black

Phthalo Blue

The contrast between different colors can be increased by contrasting their values, that is, their intensities. Here orange and blue not only contrast with each other in color (they are complementary), but both are of different intensities: the blue is darker than the orange.

1. Make a simple, but very precise, pencil drawing of an antelope; then paint the silhouette. Use a mixture of yellow and sienna.

2. With the tip of the round brush highlight the eyes, the muzzle, the ears, and the horns using a direct approach, without any shading.

3. Paint the background with phthalo blue. This is a very vibrant and intense color that contrasts vividly with orange.

4. Go over a few of the black lines with white, and also paint the eyes inside the eye socket with burnt sienna. The graphic contrast of the flat colors is easy to create with acrylics.

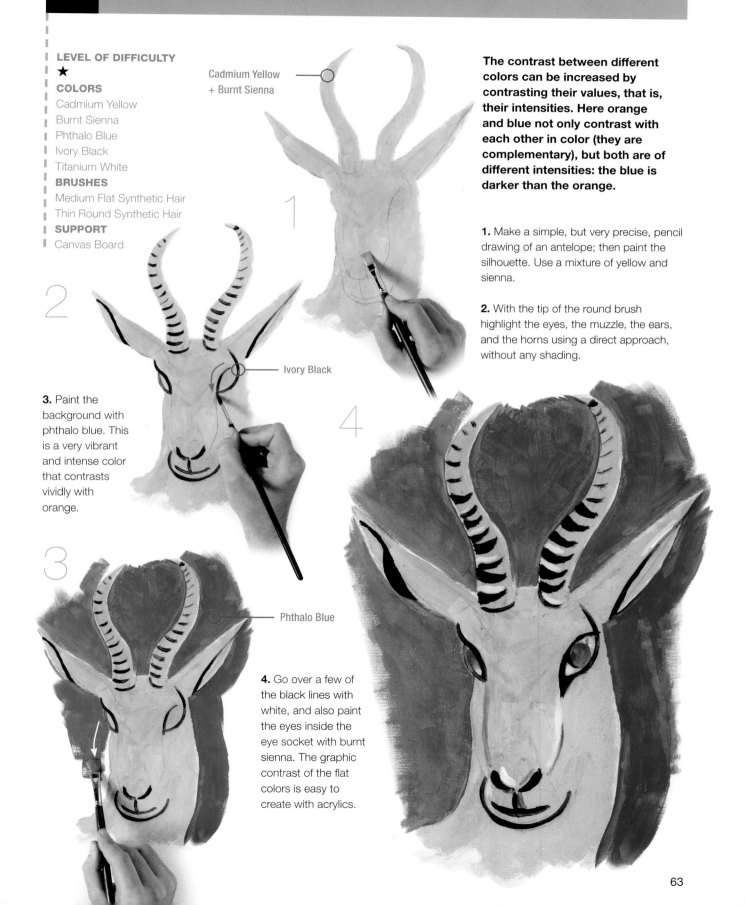

63

LEVEL OF DIFFICULTY
★ ★

COLORS
Cadmium Yellow
Burnt Sienna
Magenta
Carmine
Cobalt Violet
Titanium White

BRUSHES
Wide Flat Synthetic Hair
Medium Round Synthetic Hair

SUPPORT
Stretched Canvas

Except for the white and its bluish shades, the other colors in this exercise belong to the same warm range. However, the contrasts are very vivid because of the differences in value. To be more specific, there are several applications of pink in intensities that are very different from each other.

1. Make a pencil drawing of the cake, and create a creamy texture on it with white mixed with violet (see the inset). Then paint the lower part with pure magenta.

Magenta

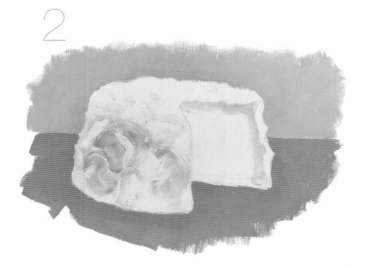

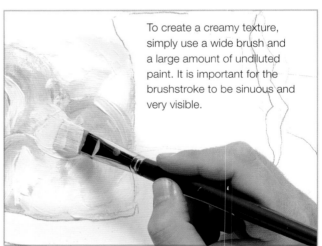

To create a creamy texture, simply use a wide brush and a large amount of undiluted paint. It is important for the brushstroke to be sinuous and very visible.

2. Paint the background with the same magenta, but lightened with white (a lighter value of the same color).

3. On top of the cake paint a few cherries dipped in the cream with carmine.

Carmine

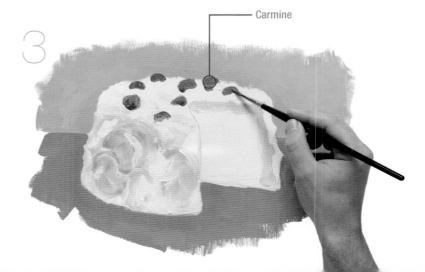

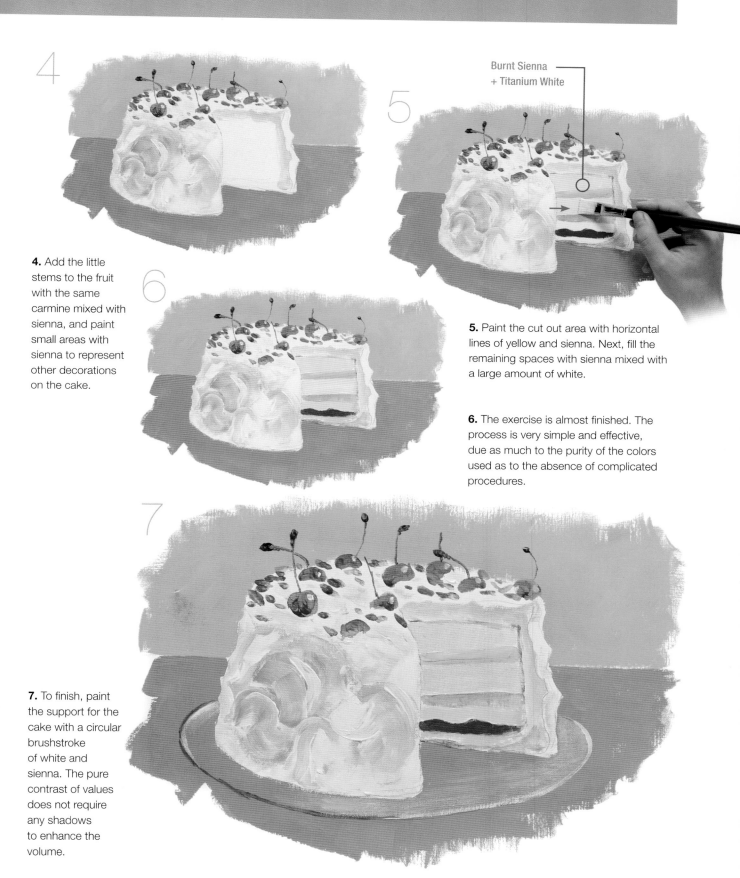

4. Add the little stems to the fruit with the same carmine mixed with sienna, and paint small areas with sienna to represent other decorations on the cake.

Burnt Sienna + Titanium White

5. Paint the cut out area with horizontal lines of yellow and sienna. Next, fill the remaining spaces with sienna mixed with a large amount of white.

6. The exercise is almost finished. The process is very simple and effective, due as much to the purity of the colors used as to the absence of complicated procedures.

7. To finish, paint the support for the cake with a circular brushstroke of white and sienna. The pure contrast of values does not require any shadows to enhance the volume.

LEVEL OF DIFFICULTY
★

COLORS
Cadmium Yellow
Permanent Red
Magenta
Permanent Green
Burnt Sienna
Titanium White

BRUSH
Large Round Hog Bristle

SUPPORT
Paper for acrylic paint

Pure color can be enough for representing the mass and volume of an object. In this example, you will use clear contrasts of pure colors, which will create a coherent and natural rendering of the subject. These bright, lively colors will be treated in a very simple manner.

1. Make a simple pencil drawing; then start painting the flowerpot with pure, saturated red, which has not been diluted. Add red mixed with yellow on the top part.

2. Use permanent green for the stems, and mix it with white for the lighter areas.

3. Leave the bases of the stems completely white. The color of the dirt will define their shapes.

Permanent Red + Cadmium Yellow

Permanent Green

Burnt Sienna

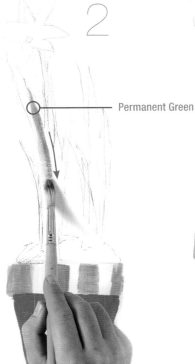

4. Finish painting the stems. The flower is cadmium yellow, the dirt should be painted with sienna, and the decoration on the flowerpot is magenta lightened with white.

LEVEL OF DIFFICULTY
★

COLORS
Cadmium Yellow
Permanent Red
Carmine
Sap Green
Cobalt Blue
Titanium White
Ivory Black

BRUSH
Fine Round Synthetic Hair

SUPPORT
Canvas Board

This exercise will be an ornamental painting based on several very simple plant and architectural motifs. The subject is just an excuse for developing several contrasts of pure color, which is one thing that acrylic paint does very well.

1. The drawing must be very simple. Leave white spaces where you can develop the colors, and reduce the objects to a series of very recognizable outlines.

2. The drawing is just a framework for supporting the colors. It is important to allow your imagination to soar and to not muddy the colors. To begin, paint the reds and yellows as architectural shapes. Then paint the palm tree with lines of equal width.

Sap Green

3. Continue to combine straight and curved shapes, plant motifs, and outlines of windows, awnings, and cornices, as if it were a very colorful theater backdrop.

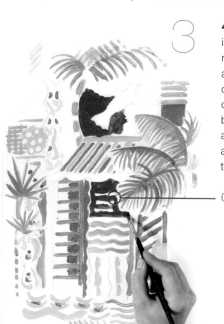

4. The result is ornamental, relaxed, and attractive. The design of a bird on the cobalt blue background adds a certain atmospheric feeling to the work.

Cobalt Blue

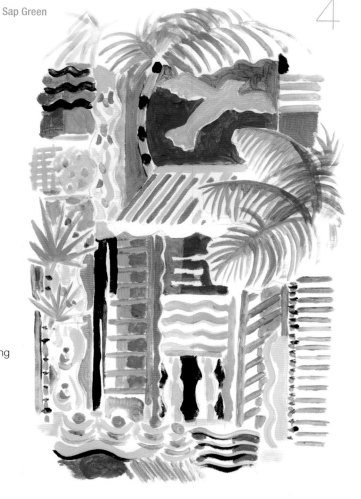

LEVEL OF DIFFICULTY
★ ★
COLORS
Ochre
Permanent Red
Magenta
Ultramarine Blue
Titanium White
Ivory Black
BRUSH
Medium Flat Synthetic Hair
SUPPORT
Paper for acrylic paint

When very dark and opaque colors are contrasted against very light transparent colors, it creates the illusion of light. This technique is very useful for colored glassware on a very dark or black table.

1. Draw the cylindrical and conical forms of the glassware. Use very diluted paint applied with a flat brush horizontally on the glasses, making thin magenta and blue brushstrokes.

2. Use thicker paint, mixtures of ochre and red, to paint the rest of the glassware in the same manner.

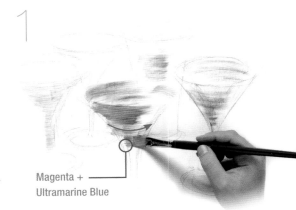

Magenta +
Ultramarine Blue

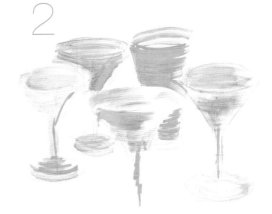

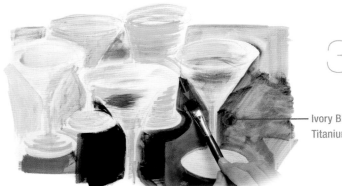

Ivory Black +
Titanium White

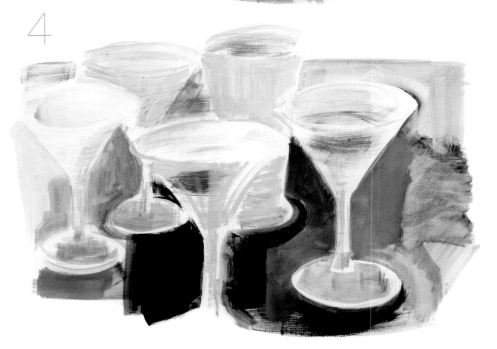

3. Define the forms of the glasses by painting the spaces between them with diluted black. Then immediately apply very dark gray, mixed from ivory black and titanium white, in some areas to represent the polished surface of the table.

4. The quick and simple rendering of the glassware demonstrates how the effect of light reflected on the glass can be easily achieved.

LEVEL OF DIFFICULTY
★

COLORS
Cadmium Yellow
Sap Green
Permanent Green
Ultramarine Blue
Cobalt Violet
Titanium White

BRUSH
Narrow Flat Hog Bristle

SUPPORT
Canvas Board

Green, as well as blue violet, belongs to the cool range, and the contrast between these two colors is particularly sophisticated. In this example, the greens are developed to their full potential by mixing them with yellow and with blue to create a large number of tones.

1. The drawing of the plant is quite detailed because it is important to clearly establish the areas for the different colors from the beginning.

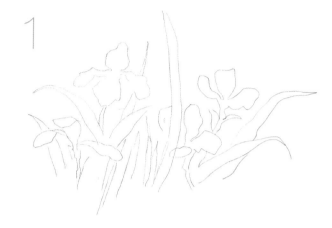

2. First paint the flowers with a mixture of violet and blue. Leave a small white area in the center of each where you can later add yellow.

Cobalt Violet +
Ultramarine Blue

3. The leaves should be painted with many different greens; the darkest are sap green mixed with a touch of blue, and the lightest are permanent green lightened with white. Use a thick mass of green shades based on the other greens for the background mixed with more white.

Ultramarine Blue
+ Permanent Green
+ Titanium White

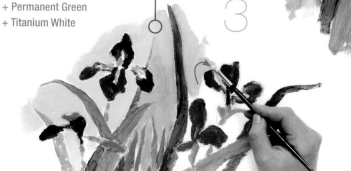

4. The background suggests the brightness of the light on the plant. The contrast between the light greens and the dark violet flowers is very attractive.

LEVEL OF DIFFICULTY
★ ★
COLORS
Lemon Yellow
Sap Green
Burnt Sienna
BRUSHES
Medium Flat Synthetic Hair
Large Round Hog Bristle
Medium Round Synthetic Hair
SUPPORT
Stretched Canvas

This exercise basically consists of developing a range of greens, from greenish yellow to the darkest green. Through the careful placement of the green values, we will create an intense multicolor effect that is very decorative.

1. The drawing is very important here, since the different values of green and green yellow will be arranged by following the outlines of the leaves in the design of the painting.

2. Paint the largest leaf with thick sap green on the illuminated half and with green mixed with sienna on the dark half. The contrast should be very strong.

3. Alternate different shades of green on the rest of the leaves, diluting them as you go.

4. Paint the background with lemon yellow mixed with a small amount of green and a touch of sienna.

Sap Green + Burnt Sienna

Lemon Yellow + Sap Green + Burnt Sienna

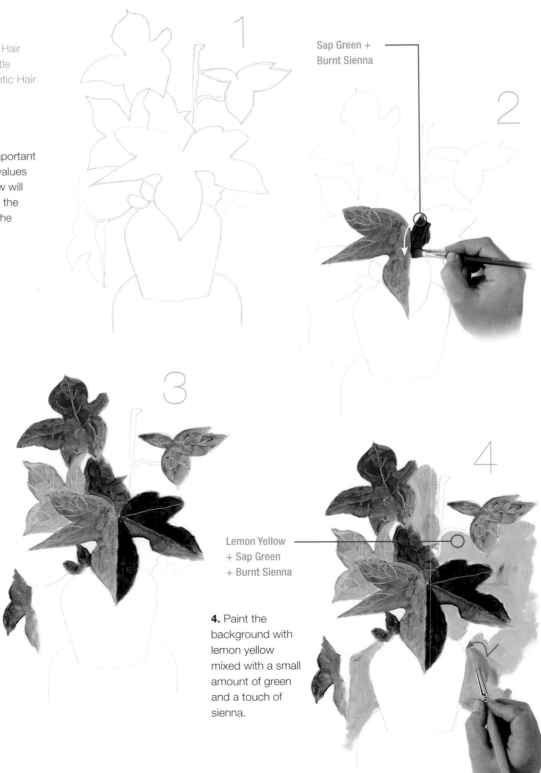

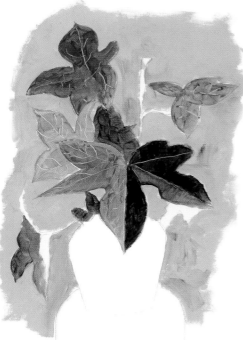

5

5. Leave the flowerpot and its stand white so you can later introduce new contrasting colors.

You can draw lines that reveal the white of the canvas by scraping the still wet paint with the handle of the brush. This will make a very fine line that suggests the veins of the leaf.

7

6. The flowerpot will be yellow mixed with green. The mixture should be uneven, and the brushstrokes should be curved to create the effect of texture.

7. In the rest of the work, use sienna for the stems and sienna mixed with yellow for the plant stand.

6

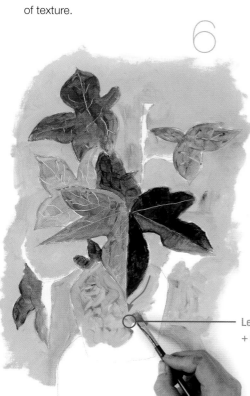

Lemon Yellow + Sap Green

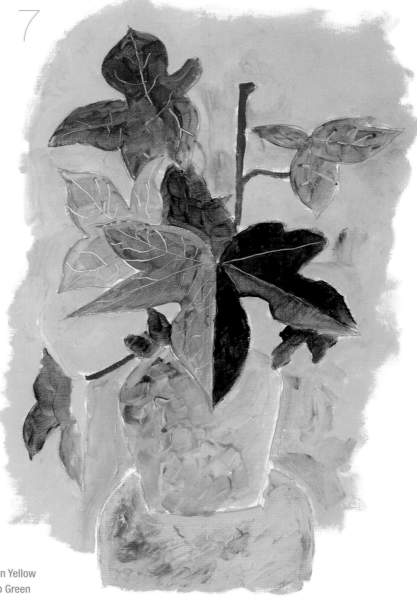

LEVEL OF DIFFICULTY

★

COLORS

Lemon Yellow

Permanent Red

Ultramarine Blue

Carmine

Sap Green

Titanium White

BRUSHES

Fine Round Synthetic Hair

Large Round Hog Bristle

SUPPORT

Paper for acrylic paint

The representation of light on objects is the same as representing their volume. In this exercise, you will create a light silhouette on three tomatoes with their shaded parts occupying the foreground of the scene.

1. Cover the lines of the drawing with light brushstrokes of very diluted red and yellow. Paint the yellow on the tops of the tomatoes.

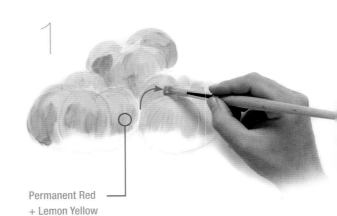

Permanent Red
+ Lemon Yellow

2. Surround the tomatoes with some strokes of ultramarine blue that has also been heavily diluted.

3. Paint the green centers of the tomatoes, and then apply a thin layer of white on the tops of each one.

Ultramarine Blue
+ Carmine

4. The white suggests the effect of light on the tops of the tomatoes. At the base, add more blue mixed with carmine to suggest the shadow projected by the tomatoes in the foreground.

LEVEL OF DIFFICULTY
★ ★
COLORS
Ochre
Sap Green
Burnt Sienna
Cobalt Blue
Titanium White
Ivory Black
BRUSH
Large Round Hog Bristle
SUPPORT
Canvas Board

Traditionally, this effect is considered to be difficult, but it can be achieved easily if you pay attention to the light and shadows of the subject. It is a matter of being able to distribute a few very strong contrasts in different areas of the painting.

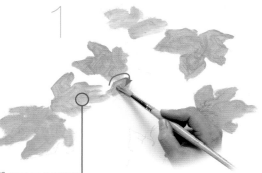

1. Start by applying a few random leaf shapes on the board. They should be a mixture of green and ochre, lightened with white.

2. Paint the middle space with blue mixed with a lot of black, but just around the leaves on the left. Cover the rest of the area with blue.

Sap Green + Ochre + Titanium White

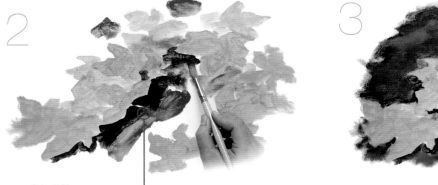

Cobalt Blue
+ Ivory Black

3. After surrounding the leaves with a mixture of blue and a little black, apply a small amount of white that has been mixed with a bit of blue and a touch of black to the blue in the center to create a gray tone that suggests light on the water of the pond.

4. Finally, paint the upper part of the composition with white to indicate light ripples on the surface of the water.

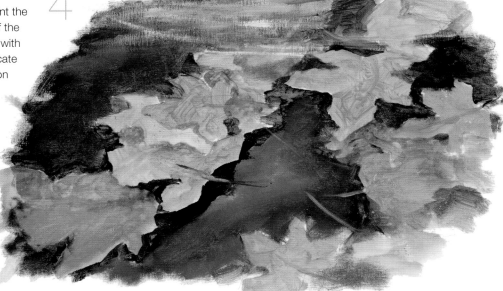

LEVEL OF DIFFICULTY
★
COLORS
Cadmium Yellow
Permanent Red
Burnt Sienna
Sap Green
Cobalt Blue
Titanium White
Ivory Black
BRUSH
Fine Round Synthetic Hair
SUPPORT
Canvas Board

Shadows seem to be of a more or less dark tone, but what is actually their real color? It is a cool color, with a blue or purple tendency, that is always related to an illuminated object and its surroundings. In this example, the shadows are not affected by any reflections and are created by a single nearby source of light.

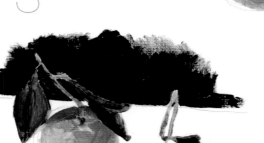

Cadmium Yellow
+ Permanent Red

Burnt Sienna
+ Sap Green

1. After making a simple line drawing, paint the mandarins with short brushstrokes of orange paint, made by mixing yellow and red. The red should be stronger on the shaded parts.

2. Paint the darkest areas with sienna and the leaves with a mixture of sienna and green.

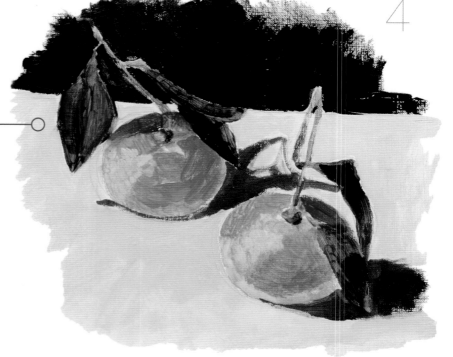

Titanium White
+ Ivory Black
+ Burnt Sienna

3. Paint the background pure black to emphasize the modeled colors.

4. The shadows are purple, made by mixing blue, red, white, and black. This tone is cooler and darker than those of the illuminated areas. The surface of the table is gray, a combination of black, white, and a bit of sienna.

LEVEL OF DIFFICULTY
★
COLORS
Cadmium Yellow
Permanent Red
Sap Green
Permanent Green
Magenta
Ultramarine Blue
Titanium White
Ivory Black
BRUSH
Fine Round Synthetic Hair
SUPPORT
Canvas Board

Outdoors and in full light, the multiple reflections of the surfaces create light shadows and variable tones. Here, we will use an Impressionist approach to paint a rich, luminous subject.

Permanent Green
+ Sap Green
+ Ultramarine Blue

1. The preliminary drawing should be a group of pencil lines that indicate different directions without actually defining any outlines. Begin painting with a mixture of permanent green, sap green, and blue, lightened with a small amount of white.

2. The brushstrokes will be of varying intensities depending on the amount of white in them, and they will indicate the directions and sizes of the leaves.

Ultramarine Blue
+ Permanent Red
+ Titanium White

Permanent Red
+ Titanium White

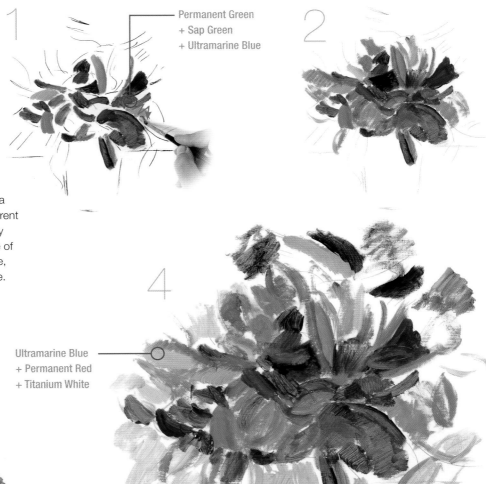

3. Add some areas of purple (mixed from red, blue, black, and white) to suggest the petals of the flower.

4. Paint the flowerpot with yellow mixed with a little red; then render the shadows with a light mauve mixed from magenta and blue and lightened with white. The brightness of the shadows expresses the sunny outdoors.

LEVEL OF DIFFICULTY
★ ★

COLORS
Permanent Red
Ultramarine Blue
Titanium White
Ivory Black

BRUSH
Flat Medium Synthetic Hair

SUPPORT
Stretched Canvas

The following exercise addresses the representation of a seascape on a stormy day. It is divided into two phases, which are seen on this double page and the following two. In this first phase, you will paint the light that is seen in the sky in the final hours of the day.

1. Mix permanent red with a large amount of white, and paint two large horizontal bands in the center of the support, which will correspond to the lower part of the sky and the sea.

1

Permanent Red
+ Titanium White

3

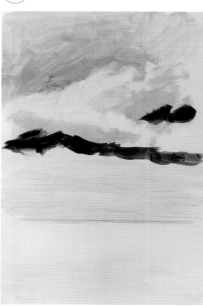

5

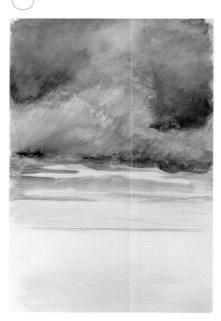

2

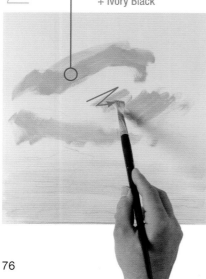
Titanium White
+ Ivory Black

4

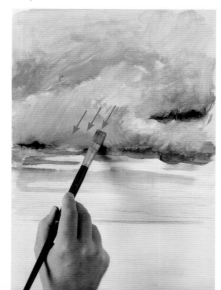

2. Paint the upper part of the sky with a light gray made by mixing black and white.

3. Add new strokes of very diluted black to the gray area and immediately mix them.

4. Make brushstrokes in all directions, without completely blending the brush marks. These marks will help you create the desired effect.

5. Begin to darken the sky little by little, by adding darker and darker tones.

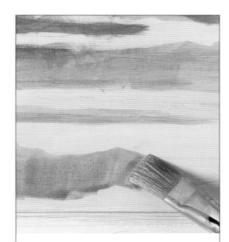

The simplest effects are created with simple techniques. The transparency of the diluted acrylic itself will help you represent the transparency of the atmosphere in the distance.

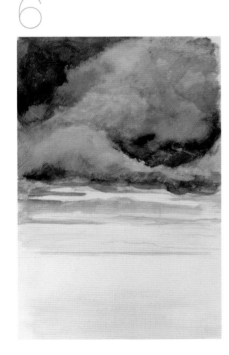

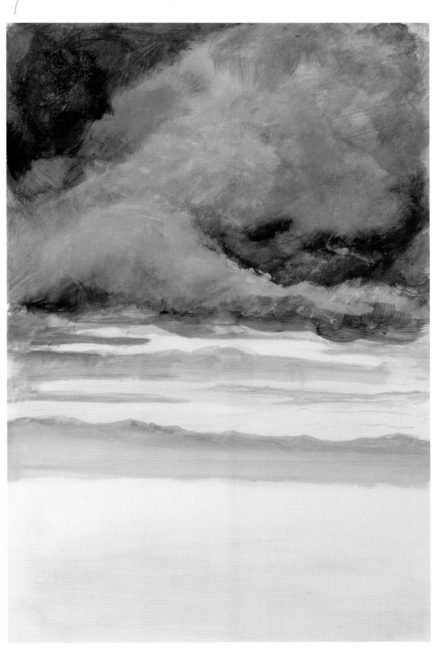

6. On the lower part of the clouds, add some very light strokes of diluted gray to represent the farthest clouds in the dusk sky.

7. Do not touch the background color. A few delicate bands of gray on the horizon and a far range of mountains of the same color as the clouds are enough to represent the faint light that dominates this moment of the day.

LEVEL OF DIFFICULTY
★ ★
COLORS
Permanent Red
Sap Green
Ultramarine Blue
Titanium White
Ivory Black
APPLICATORS
Medium Flat Synthetic Hair Brush
Very Fine Round Synthetic Hair Brush
Painting Knife
SUPPORT
Stretched Canvas

Sap Green
+ Titanium White
+ Ivory Black

Continuing the process initiated in the previous exercise, we will now give you a way to create relief through the distribution of light and shadows on the waves. The colors used are very similar to those that are in the sky, although there are a greater variety of tones.

1. Starting at the horizon line, you will create a gray base using very diluted white and black mixed with a little green. Allow the previously applied light red to be seen along the lower part of the color.

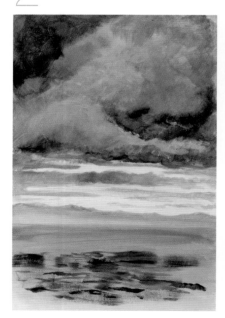

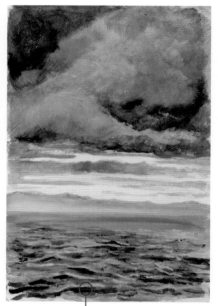

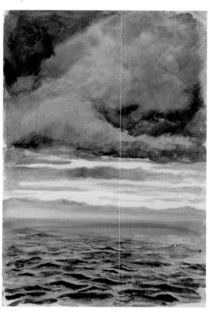

Ivory Black + Titanium White + Ultramarine Blue

2. Apply a few loose strokes of ultramarine blue and sap green that will suggest the shadows of the crests of the waves.

3. Over the previous strokes applied with the painting knife, apply some long thin strokes of different gray tones; the darkest should include green and blue in the mixture.

4. Continue adding new tones, small new light and dark strokes to represent the crest and the shadow of a wave. Thus, with patience, you will build up the surface of the sea.

The painting knife can be very useful for creating an informal effect of broken tones. The surface of an agitated sea requires a treatment of this kind.

6

5. Introduce the silhouette of a seagull or a cormorant in the distance with a fine brush to give the scene a sense of scale.

6. In the finished work, the luminosity of the sky, stormy and subtle at the same time, is very convincing. The relief of the waves moving off toward the horizon can now be appreciated.

5

Ivory Black

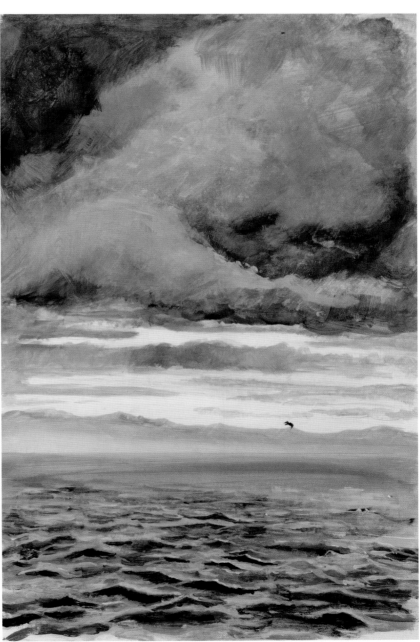

LEVEL OF DIFFICULTY
★ ★
COLORS
Ochre
Burnt Sienna
Permanent Red
Sap Green
Cobalt Blue
Cobalt Violet
Titanium White
BRUSHES
Wide Flat Synthetic Hair
Fine Round Synthetic Hair
SUPPORT
Canvas Board

The effect of light on the relief of a face is a common challenge in painting. Painting it with acrylic paint is not too difficult a task; you just have to create the right bases of color.

1. Draw the head, covered with a large hat, and add the features of the face. Then begin painting with a mixture of sienna, ochre, and white.

Burnt Sienna + Ochre + Titanium White

2. Use the same mixture, with a little added white, to paint the cheeks, the bridge of the nose, and the shadow of the neck.

3. We have added more white in the central parts of the face and the neck. In this first phase, you must work quickly to blend the tones before they dry.

4. Paint the brim of the big hat with two cool colors (permanent red and cobalt violet), so they will contrast with the flesh tones on the face.

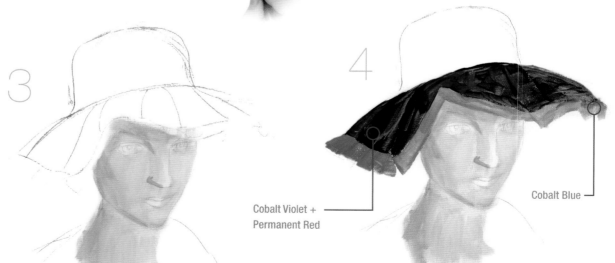

Cobalt Violet + Permanent Red

Cobalt Blue

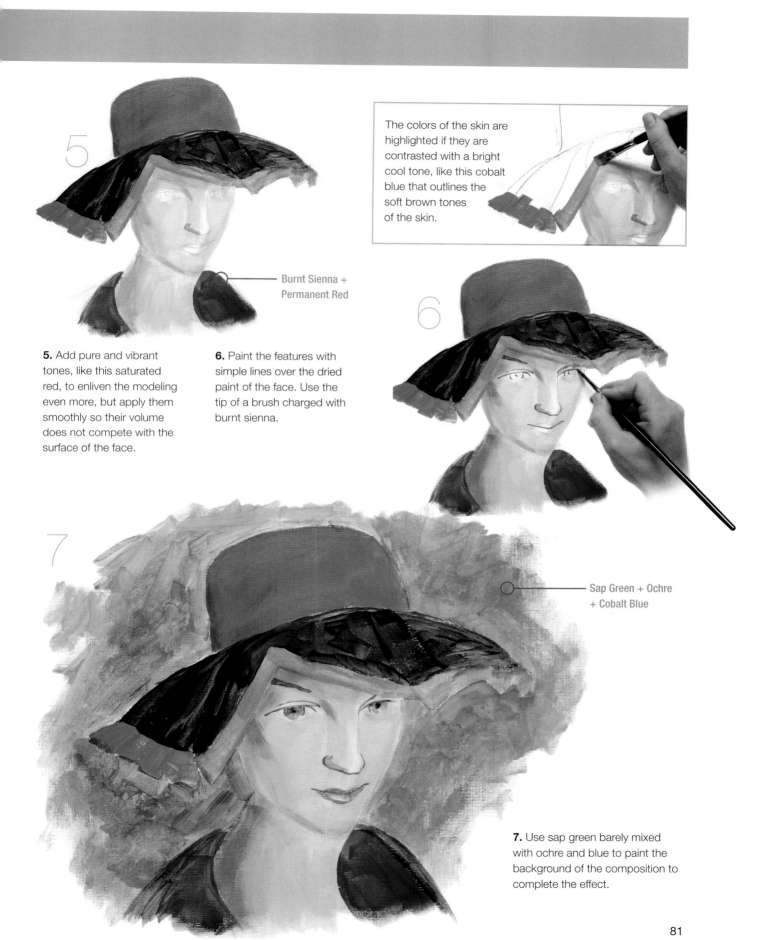

The colors of the skin are highlighted if they are contrasted with a bright cool tone, like this cobalt blue that outlines the soft brown tones of the skin.

Burnt Sienna + Permanent Red

5. Add pure and vibrant tones, like this saturated red, to enliven the modeling even more, but apply them smoothly so their volume does not compete with the surface of the face.

6. Paint the features with simple lines over the dried paint of the face. Use the tip of a brush charged with burnt sienna.

Sap Green + Ochre + Cobalt Blue

7. Use sap green barely mixed with ochre and blue to paint the background of the composition to complete the effect.

LEVEL OF DIFFICULTY
★

COLORS
Lemon Yellow
Ochre
Sap Green
Burnt Sienna
Titanium White
Ivory Black

BRUSHES
Medium Flat Synthetic Hair
Fine Round Synthetic Hair

SUPPORT
Canvas Board

A form lit from a single source shows two very different outlines: one light and the other dark. The following exercise is a cat represented with a very simple kind of chiaroscuro that is easy to achieve.

1. It is important to simplify the shape of the cat as much as you can so that the effect will be clear and defined. This drawing of the cat is very concisely drawn.

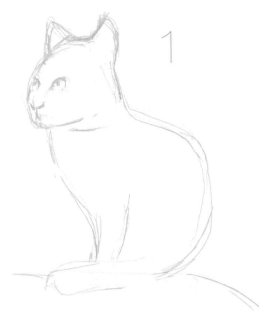

2. Paint the body with a thick mixture of ochre and sienna. They should be only partially mixed so that you can see shades of both colors.

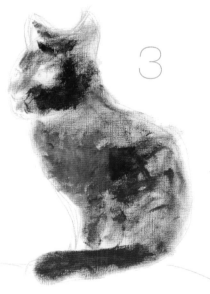

3. Use a brush charged with sienna to paint the interior of the feline, making very quick motions and not completely covering the support.

4. Then paint the backside of the cat with the same sienna mixed with some black.

Burnt Sienna + Ochre

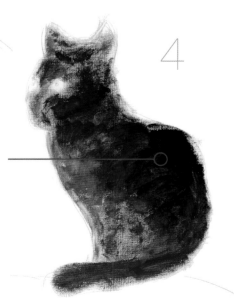

Burnt Sienna
+ Ivory Black

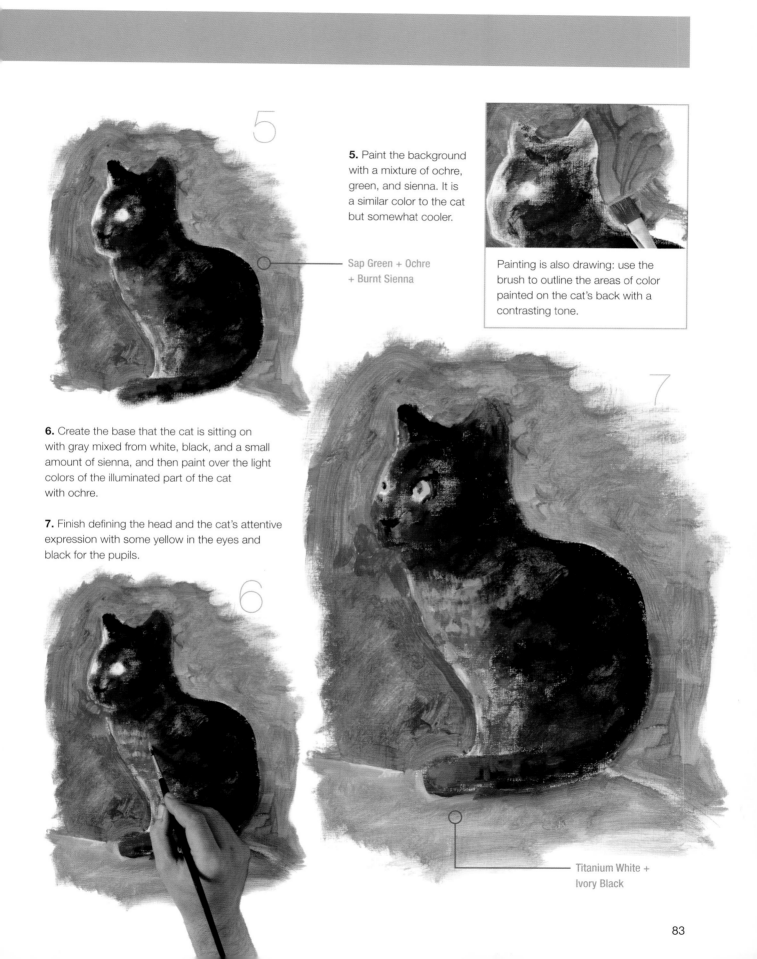

5. Paint the background with a mixture of ochre, green, and sienna. It is a similar color to the cat but somewhat cooler.

Sap Green + Ochre + Burnt Sienna

Painting is also drawing: use the brush to outline the areas of color painted on the cat's back with a contrasting tone.

6. Create the base that the cat is sitting on with gray mixed from white, black, and a small amount of sienna, and then paint over the light colors of the illuminated part of the cat with ochre.

7. Finish defining the head and the cat's attentive expression with some yellow in the eyes and black for the pupils.

Titanium White + Ivory Black

LEVEL OF DIFFICULTY
★
COLORS
Lemon Yellow Cobalt Blue
Sap Green
Burnt Sienna
Ultramarine Blue
Titanium White
Ivory Black
BRUSHES
Medium Flat Synthetic Hair
Fine Round Synthetic Hair
SUPPORT
Paper for acrylic paint

The relief and even the volume of objects can be represented without resorting to conventional shading. A few contrasting values can be enough to create this effect. This exercise demonstrates how to render the light and the volume.

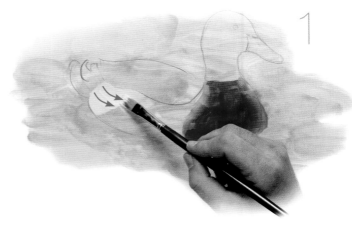

1. Make a very simple sketch of the duck, and apply a large area of very diluted sienna mixed with a little blue lightened with white. Then paint the plumage on the chest with sienna, and apply white on the sides.

2. For the head, use a mixture of green, blue, and black. This is a very dark tone that will emphasize the contrasting values and suggest relief on the duck.

3. Darken the inner edges of the wings to suggest the volume of the body.

Cobalt Blue

Burnt Sienna +
Ultramarine Blue

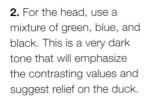

4. With just a few steps, you have achieved a result that shows a certain relief and makes the duck stand out against the background, without shading or actual modeling.

LEVEL OF DIFFICULTY
★

COLORS
Cadmium Yellow
Ochre
Sap Green
Burnt Sienna
Phthalo Blue
Titanium White
Ivory Black

BRUSH
Fine Round Synthetic Hair

SUPPORT
Canvas Board

Concavity and convexity are the two most important effects of modeling: volumes that push out and hollows that sink in. In the following example, you will work with both in a simple and direct way.

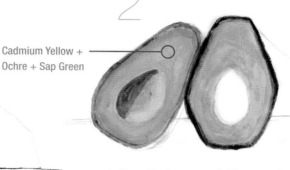

Cadmium Yellow +
Ochre + Sap Green

1. Draw the two halves of the avocado. Start painting from the outside: a green edge that progressively becomes lighter through the addition of ochre and white.

2. To create the cavity, you just have to place an area of sienna next to another of the same color mixed with white.

Phthalo Blue +
Titanium White

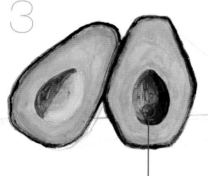

Burnt Sienna

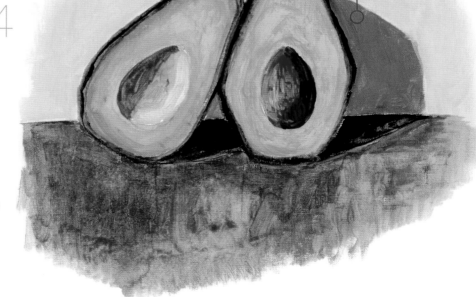

3. The convex avocado pit is created in a similar manner: gradually go from sienna mixed with ochre to pure sienna on the opposite side.

4. Paint the outside edge of the avocado with green mixed with a small amount of black. The base is blue straight from the tube, but it is mixed with black and white to paint the shadows.

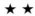

LEVEL OF DIFFICULTY
★ ★

COLORS

Permanent Red

Lemon Yellow

Ochre

Sap Green

Burnt Sienna

Titanium White

Ivory Black

BRUSHES

Fine Round Synthetic Hair

Wide Flat Synthetic Hair

SUPPORT

Stretched Canvas

This still life of fruit, which shows a great amount of relief, is a good starting point for developing your chiaroscuro technique. The sizes and the colors of each piece determine their relief; some fruit blends in with its neighbors, while the volumes of others strongly stand out.

1. Paint a general tone over the pencil drawing. Use sienna diluted with water and lightened with white.

Burnt Sienna

Ochre +
Permanent Red

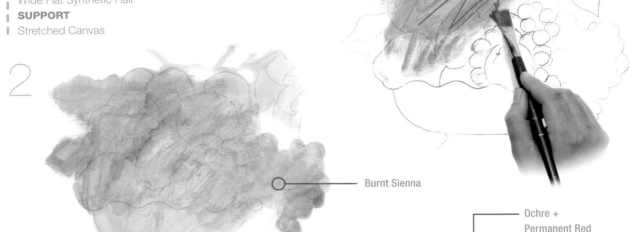

2. This base color will help to promote the color harmony of the still life.

3. For the green fruit, use a mixture of sap green and a little ochre.

4. The red fruit also contains a little ochre in their tones. Treat all the colors in the same way: give them similar values, and do not make them contrast with each other very much.

Sap Green
+ Ochre

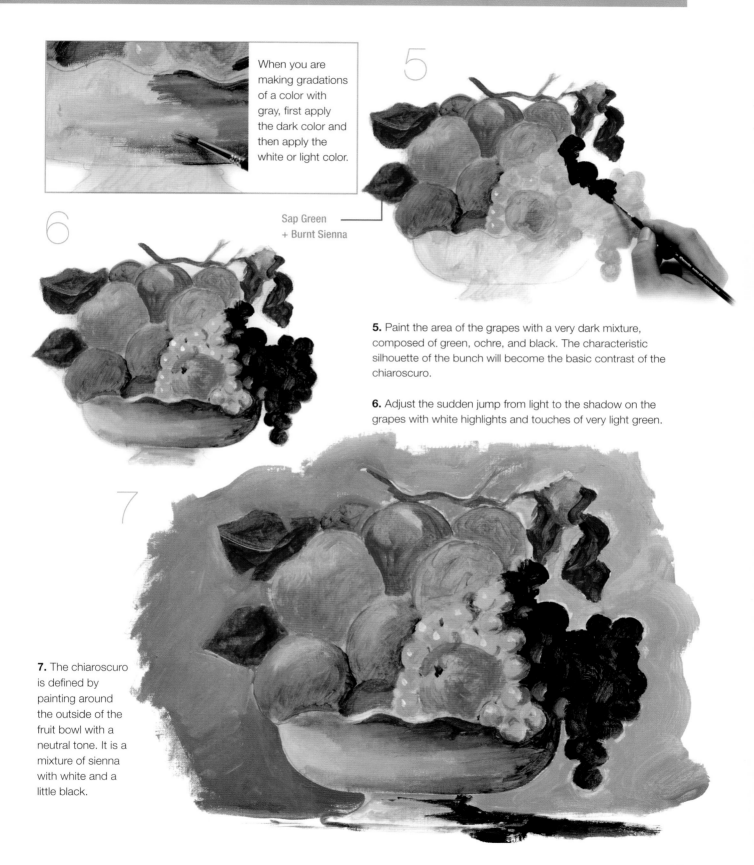

When you are making gradations of a color with gray, first apply the dark color and then apply the white or light color.

Sap Green + Burnt Sienna

5. Paint the area of the grapes with a very dark mixture, composed of green, ochre, and black. The characteristic silhouette of the bunch will become the basic contrast of the chiaroscuro.

6. Adjust the sudden jump from light to the shadow on the grapes with white highlights and touches of very light green.

7. The chiaroscuro is defined by painting around the outside of the fruit bowl with a neutral tone. It is a mixture of sienna with white and a little black.

COLORS
Permanent Red
Carmine
Cobalt Violet
Ochre
Sap Green
Burnt Sienna
BRUSHES
Medium Round Synthetic Hair
Fine Round Synthetic Hair
SUPPORT
Paper for acrylic paint

The characteristic agility of acrylic painting allows you to address the color in a very spontaneous and direct manner, without a previous drawing and with a wide margin for making changes and corrections during the process.

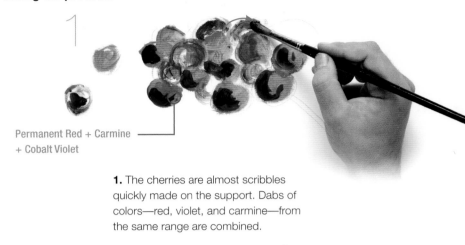

Permanent Red + Carmine
+ Cobalt Violet

1. The cherries are almost scribbles quickly made on the support. Dabs of colors—red, violet, and carmine—from the same range are combined.

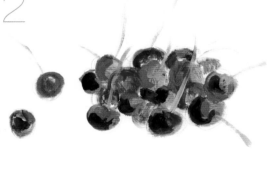

2. Use a little ochre to draw some stems to help detail the distribution of the fruit.

3. Just a few brushstrokes are enough to define each leaf.

Sap Green

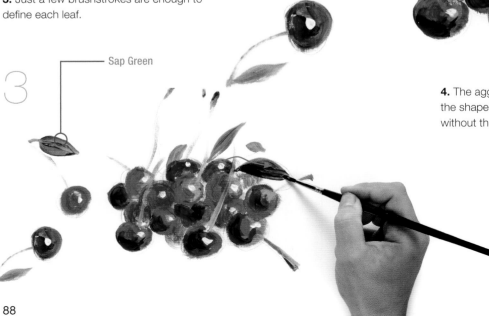

4. The agglomeration of paint suggests the shapes and colors of each cherry without the need for precise edges.

LEVEL OF DIFFICULTY
★
COLORS
Cobalt Blue
Sap Green
Ultramarine Blue
Ivory Black
BRUSHES
Flat Wide Synthetic Hair
Fine Round Synthetic Hair
SUPPORT
Canvas Board

The brush marks and the different variations of color left by them can be enough to evoke the volume of the subject being painted. This hummingbird was made with just a few applications of color, using diluted paint colors that barely blend with each other.

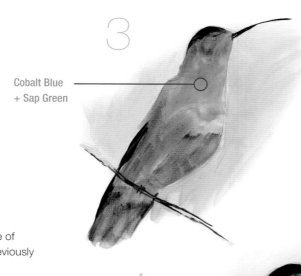

Cobalt Blue + Sap Green

3. Draw the beak and the branch with the tip of the round brush, charged with a thicker mixture of blue and black.

1. Some quick brushstrokes of very diluted blue mixed with black are painted over a very simple drawing to establish the background of the composition. .

2. Paint the body of the bird with a mixture of blue and green. Then use the gray you previously mixed to paint the belly and the tail.

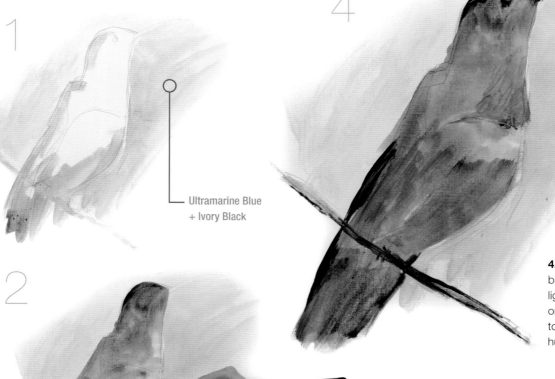

Ultramarine Blue + Ivory Black

4. Use the fine brush to add some light brushstrokes on the chest and to define the hummingbird's eye.

COLORS
Lemon Yellow
Ochre
Permanent Red
Carmine
Sap Green
Ultramarine Blue
Titanium White
BRUSH
Medium Flat Synthetic Hair
SUPPORT
Paper for acrylic paint

It is possible to depict simple forms in a convincing manner with just a few brushstrokes. When the brushstrokes simultaneously define the form and the color, it is not necessary to go into detail to achieve an accurate representation.

1. Paint the darkest apples with red and yellow, using vertical brushstrokes that blend the two colors.

Permanent Red + Lemon Yellow

2. Add a few apples that are simple areas of color with very light green and also yellow mixed with white. Do not model them.

Sap Green + Lemon Yellow + Titanium White

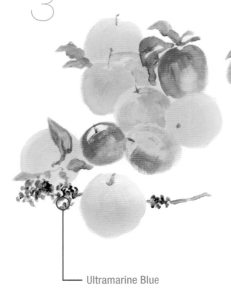

Ultramarine Blue

3. The secret is in enhancing the areas of color with simple representations of stems and leaves, using a mixture of green and ochre.

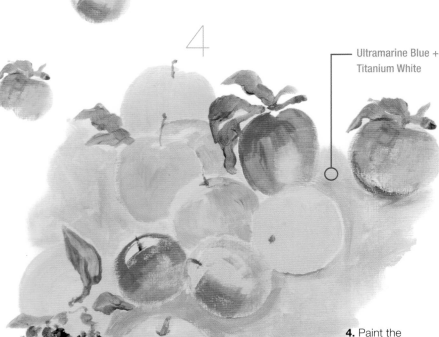

Ultramarine Blue + Titanium White

4. Paint the background of the composition with a very light blue to contrast with all the warm colors.

LEVEL OF DIFFICULTY
★
COLORS
Lemon Yellow
Sap Green
Permanent Red
Burnt Sienna
Titanium White
BRUSHES
Wide Flat Synthetic Hair
Large Round Hog Bristle
SUPPORT
Paper for acrylic paint

In this exercise, we take advantage of the spaces left white on the paper to give the painting luminosity and cause the colors to vibrate. The brushstrokes are not realistic; they simply suggest the foliage.

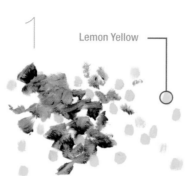

Lemon Yellow

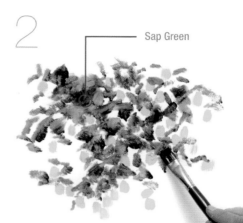

Sap Green

1. There is no need for a preliminary drawing; just distribute small yellow areas of color in the places where the lemon tree will be.

2. . Add dabs of green around the yellow paint, by tapping the paper with the hair of the flat brush.

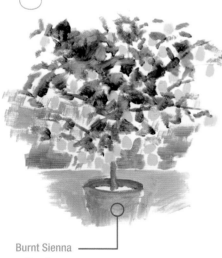

Burnt Sienna
+ Sap Green
+ Titanium White

Permanent Red
+ Burnt Sienna
+ Titanium White

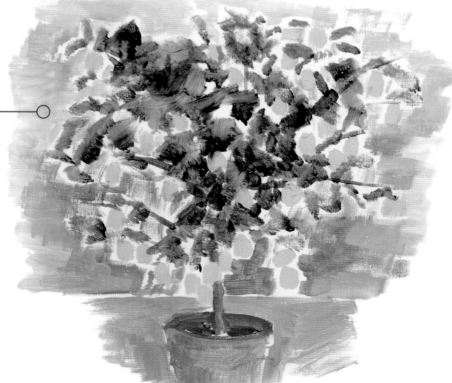

3. Paint the planter and the trunk of the lemon tree with a mixture of sienna, green, and white. Then lighten the same color, and use it for the base of the tree.

4. Apply touches of colors that are similar to the ones you have already used, mixing red, sienna, and white.

LEVEL OF DIFFICULTY
★
COLORS
Ochre
Burnt Sienna
Titanium White
Ivory Black
BRUSHES
Wide Flat Synthetic Hair
Fine Round Synthetic Hair
SUPPORT
Stretched Canvas

Representing the fur of an animal can consist of, for example, imitating the disordered locks and strands with brushstrokes that are equally disordered, or ordered in the same direction as the model.

Burnt Sienna + Ochre

1. Paint wide strokes of sienna mixed with ochre to create the dark areas of the dog. The brushstrokes should be broken up and emphasize one color or the other.

2. Add more ochre, making sure that the brushstrokes are very visible, since they will determine the final effect of the fur.

Burnt Sienna + Titanium White

3. The light hair is a mixture of sienna and a lot of white. The tan shades they create suggest the thickness of the fur.

4. Add some "frayed" strokes of pure white over the dark colors to represent the strands of hair. The details of the head are done with black and the base is a mixture of white and black.

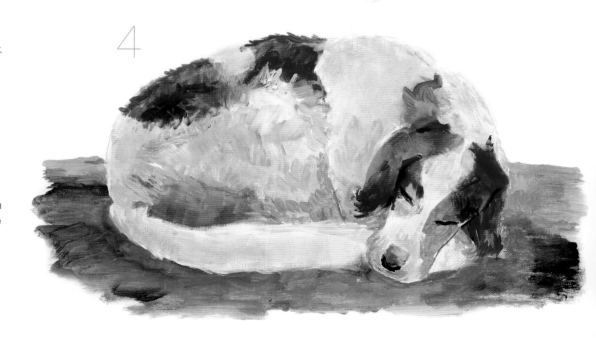

LEVEL OF DIFFICULTY
★
COLORS
Permanent Red
Cobalt Blue
Ivory Black
Titanium White
BRUSHES
Wide Flat Synthetic Hair
Very Fine Round Hog Bristle
SUPPORT
Canvas Board

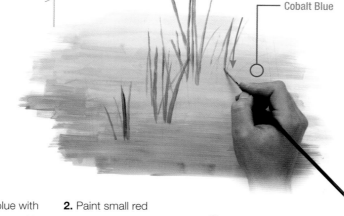

Cobalt Blue

Accuracy in representing reflections is dependent on their tones, which are always darker than those of the objects reflected, and on their symmetrical placement. This floral motif very simply demonstrates this technique.

Permanent Red + Titanium White

1. Apply a large area of cobalt blue with horizontal strokes. Then draw some thin green brushstrokes to define the stems.

2. Paint small red petals of similar sizes and shapes around the stems.

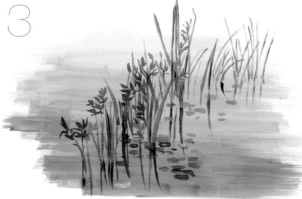

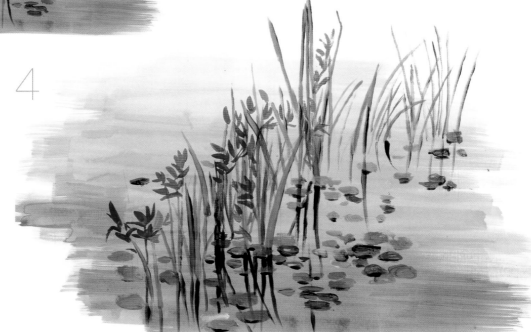

3. Use a mixture of red and blue to paint the reflections of the stems. They should be symmetrical and a little shorter than the real plants.

4. Add a few water lilies and their corresponding shadows. These shadows are small marks, painted in blue mixed with green on the underside of each lily.

LEVEL OF DIFFICULTY
★

COLORS
Lemon Yellow
Magenta
Permanent Red
Sap Green
Cobalt Blue
Ultramarine Blue
Titanium White

BRUSH
Medium Round Synthetic Hair

SUPPORT
Stretched Canvas

This is the first part of a process that continues on the following pages. It consists of painting a landscape divided into two large planes on the canvas. In this first plane, we use paint to create a rich tapestry of multiple colors.

When representing wooded mountains or distant planes, you must be aware of the size of the brushstrokes: they should be progressively larger as you paint nearer planes, to suggest the sizes of the trees.

1

2

Magenta +
Lemon Yellow

3

Magenta + Cobalt Blue
+ Titanium White

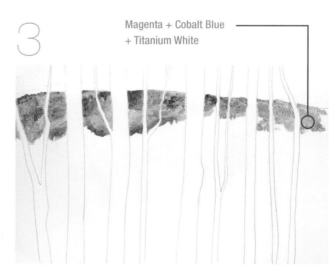

1. The drawing mainly consists of outlining the tree trunks in the foreground. The background does not require a drawing because you will create it entirely with color.

2. First, paint the pinkish tones of this forest in autumn, using magenta and yellow. The shades you see are the result of mixing these two colors in different proportions.

3. The area of the farthest mountains will have a cooler tone: cobalt blue occasionally mixed with a little magenta. The forms are reduced to the shapes of the brush marks, since there is no need to individualize each tree.

4. As you get closer to the lower part of the composition, the colors become warmer. Here you will use a mixture of red and yellow.

5. In the lower part, use the yellows straight from the tube, and even farther down apply greens that are partially mixed with yellows. Here the brushstrokes should be larger in size.

6. Finally, use pure cobalt blue diluted in quite a bit of water. This very bright and luminous color will strongly contrast with the greens and yellows.

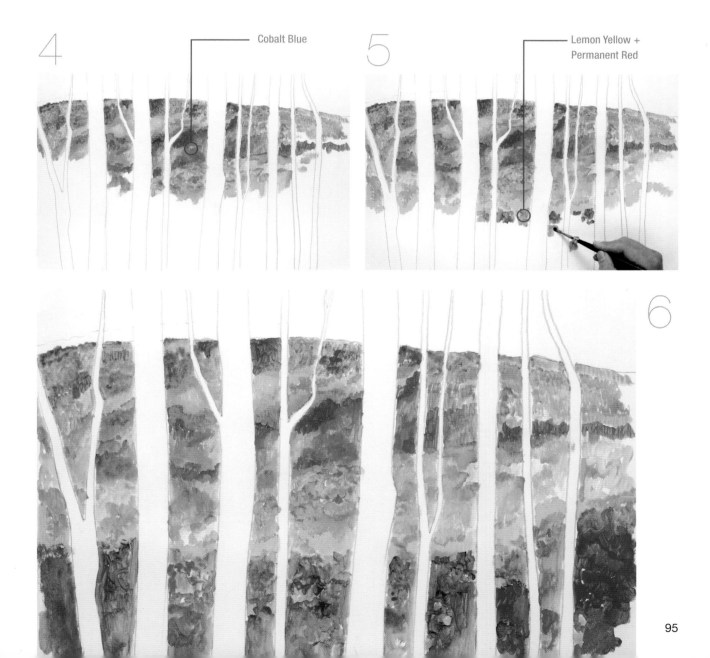

4

Cobalt Blue

5

Lemon Yellow + Permanent Red

6

To continue with the previous exercise, you will now resolve the foreground of the landscape using silhouetted forms in a much darker tone than was used in the background. With this approach, you can define and show the deep space without using any type of perspective.

1. Paint the near trees with a very thick mixture of cobalt blue, ultramarine blue, and black, allowing the accumulated brush marks to show. Use a mixture of ultramarine blue and violet on the next tree.

2. Add a little green to the blue and violet mixture to create dark shades that are a little warmer, to suggest the bark of the trees.

Ultramarine Blue + Ivory Black

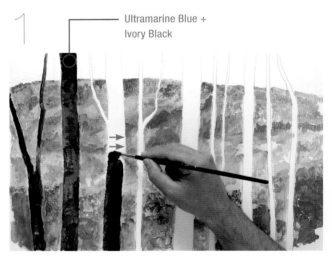

Ultramarine Blue + Sap Green + Ivory Black

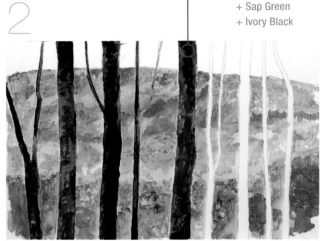

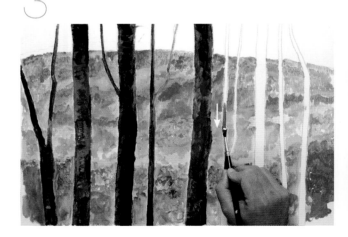

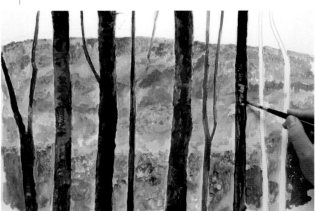

3. Indicate the branches and more distant trees with a single stroke of the brush.

4. Paint the silhouette of this tree with a mixture of ultramarine blue and black, and add small white brushstrokes to show a little bit of modeling.

In very colorful works of art, the whites should be blended with very light grays so that the brush marks can be seen; otherwise, the continuous texture of the brushstrokes will be interrupted.

5. Use several combinations of the previous colors to finish the silhouettes of all the trees. They will now strongly express the space between the planes of the composition.

6. Now all that is left to paint is the sky. Reserve some large white areas and apply thick cobalt blue to the rest of the sky.

7. To finish, slightly darken the clouds with very light gray.

5

Sap Green
+ Ivory Black

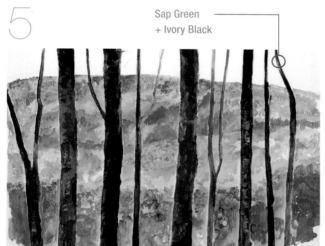

6

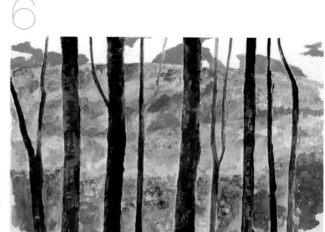

7

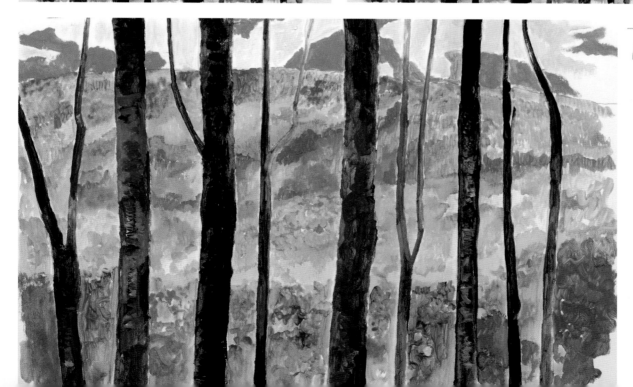

LEVEL OF DIFFICULTY
★
COLORS
Lemon Yellow
Carmine
Burnt Sienna
Sap Green
Cobalt Blue
Titanium White
Ivory Black
BRUSHES
Medium Round Synthetic Hair
Fine Round Synthetic Hair
SUPPORT
Paper for acrylic paint

Perspective is the traditional method of representing space. Here, all the surfaces in perspective maintain their colors, except for the plane of the sky, which can only express perspective through gradations of color.

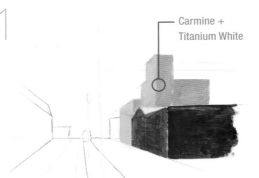

Carmine +
Titanium White

1. Draw the lines of perspective that converge at a central point. The surfaces are large blocks that you will paint alternately with carmine and white, and sienna, and carmine.

2. The surfaces that are parallel to our point of view should be darker. The ones that move toward the horizon should alternate different shades of the same color. The gray paint should be very thick to emphasize the brush marks.

Cobalt Blue +
Titanium White

Carmine +
Cobalt Blue +
Titanium White

3. The cobalt blue of the sky should be lighter as it moves toward the horizon, so you should mix it with more and more white as it progresses.

4. Add yellow poles that clearly mark the planes in the space.

Ivory Black

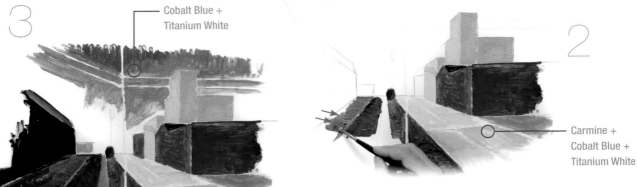

LEVEL OF DIFFICULTY
★
COLORS
Cobalt Blue
Titanium White
Ivory Black
BRUSH
Medium Flat Synthetic Hair
SUPPORT
Canvas Board

Here you will use simple brushstrokes of bluish grays to represent this seagull. These strokes are reduced to their simplest form, and they will allow you to express all the forms of the body of the bird and its coloring.

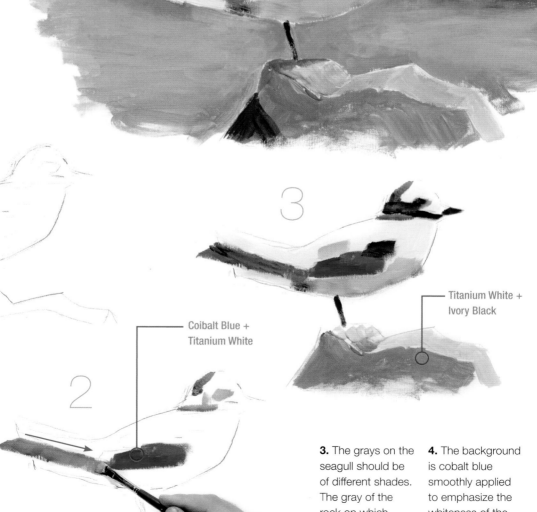

4

1. The drawing should be a very brief treatment. The sketch will just be a series of meaningful straight and curved lines.

1

3

Titanium White +
Ivory Black

Coibalt Blue +
Titanium White

2

2. With a mixture of blue, white, and black, apply a few simple lines that are more like wide brushstrokes of thick paint.

3. The grays on the seagull should be of different shades. The gray of the rock on which the bird is posing should also be different.

4. The background is cobalt blue smoothly applied to emphasize the whiteness of the feathers.

Colors that are clustered in small areas are seen as forms from a certain distance. Here the forms and planes in this landscape are created with different clusters of colors that form the composition.

1. Apply a mass of yellow brushstrokes, and above them incorporate a scattered cloud of small dabs of blue lightened with white.

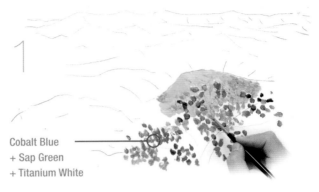

Cobalt Blue + Sap Green + Titanium White

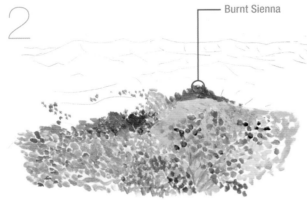

Burnt Sienna

Burnt Sienna + Lemon Yellow

2. Add more touches of yellow among the blue brushstrokes; then introduce some light brown values made by mixing sienna with red and white.

3. Each new plane will have new colors: the greens in the middle ground give way to new shades of yellow mixed with sienna to suggest the mountains

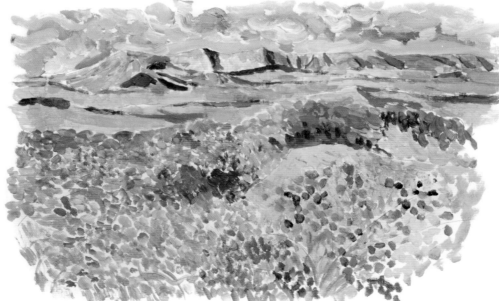

4. You will find blues in the sky, but also among the yellow and sienna brush marks in the mountains. This will add relief to a composition that is essentially chromatic.

LEVEL OF DIFFICULTY
★
COLORS
Lemon Yellow
Permanent Red
Sap Green
Permanent Green
Ultramarine Blue
Titanium White
BRUSHES
Medium Flat Synthetic Hair
Large Round Hog Bristle
SUPPORT
Paper for acrylic paint

One way of creating a three-dimensional effect is by using planes of color. In this exercise, you will simplify the subject with a series of planes of different colors, tones, and shapes.

1. Without a preliminary drawing, begin applying large areas of yellow mixed with white, and surround them with some strokes of sap green that has also been lightened.

Lemon Yellow
+ Titanium White

2. The leaves are long and of different shades made by mixing in more or less white.

Sap Green +
Permanent Green
+ Titanium White

3. Paint the base the vase is sitting on with a mixture of blue, white, and a bit of permanent green.

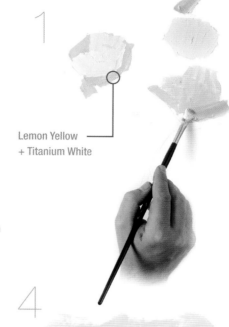

4. Paint the large glass vase with the same color as the base, but much lighter.

Permanent Red
+ Titanium White

Ultramarine Blue
+ Titanium White
+ Sap Green

LEVEL OF DIFFICULTY
★

COLORS
Ochre
Cadmium Yellow
Permanent Red
Carmine
Magenta
Cobalt Blue
Permanent Green
Titanium White
Ivory Black

BRUSHES
Fine Round Synthetic Hair
Wide Flat Synthetic Hair

SUPPORT
Canvas Board

Ochre ———

1. Draw the table and the rest of the objects with quick brushstrokes of ochre paint.

You can use large amounts of acrylic paint from the very beginning of the painting without danger that the colors will muddy each other. In this exercise, you will use masses of thick paint in contrasting colors.

Cadmium Yellow + Cobalt Blue

2. Paint the tabletop yellow and blue without defining the shape, just to create an effect with the contrasting colors.

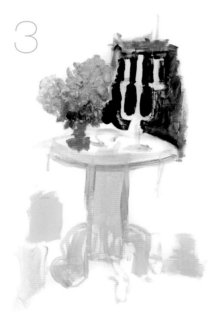

Cobalt Blue + Permanent Green + Titanium White

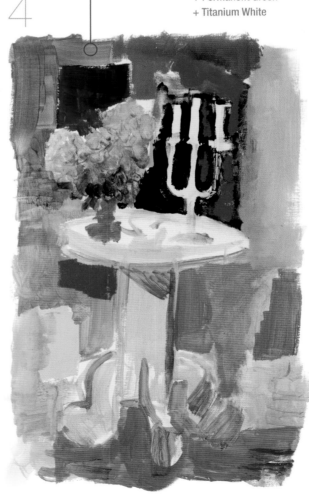

3. The candelabra is not painted, but created with a large black area that outlines its white silhouette. Add several areas of yellow in the lower part of the composition.

4. The large areas of warm colors (yellow, red, and magenta) occupy the foreground, while the contrasting cool colors (blues, grays, and blue greens) are arranged in blocks in the background of the scene.

LEVEL OF DIFFICULTY
★
COLORS
Carmine
Ultramarine Blue
Titanium White
Ivory Black
BRUSHES
Fine Round Synthetic Hair
Large Round Hog Bristle
SUPPORT
Canvas Board

This seaport scene will be painted by blocking in the outlines. This approach emphasizes the graphic strength of the image by closing the areas of color in strong simple shapes.

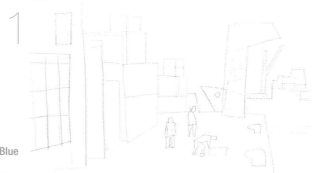

1. The drawing is simple but very complete. It is important to mark all the lines that will later be painted in black.

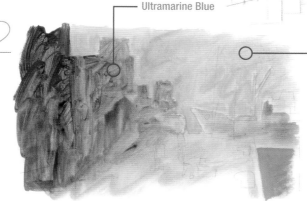

Ultramarine Blue

Carmine + Titanium White

2. Paint large areas with blues and pinks with different intensities. The fading effect will be corrected later when you apply the outlines.

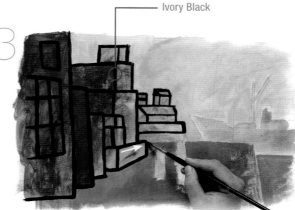

Ivory Black

3. Go over the lines with black. What were before faint variations in an overall color are now localities with distinct shades that are enclosed in each of the shapes.

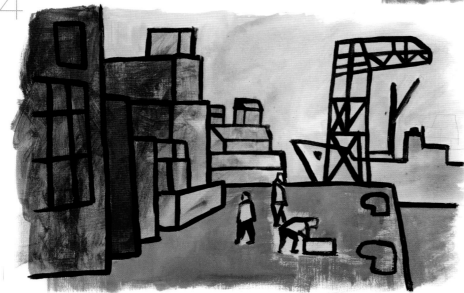

4. The clarity and graphic strength of this technique make it a very useful and interesting approach for making posters and projects of a similar nature.

LEVEL OF DIFFICULTY
★ ★

COLORS
Permanent Red
Burnt Sienna
Ultramarine Blue
Titanium White
Ivory Black

BRUSHES
Medium Flat Synthetic Hair
Fine Round Synthetic Hair

SUPPORT
Stretched Canvas

In this exercise, you will attempt a very graphic representation, based on the repetition of similar modules (the buildings) that have enough variation among them to be believable from a realist point of view. This technique will be combined with making reserves by masking.

1. Draw a grid of buildings that repeat a vertical rectangular module. Distribute the different sizes in a harmonious pattern.

2. Attach small pieces of adhesive tape. Paint each rectangle with blue diluted with water in different amounts to create different tones.

3. Continue covering the support until all the rectangles have been painted in different shades of blue.

4. The rooftops are a mixture of sienna, red, and white in different proportions to create the tones of light and shadow.

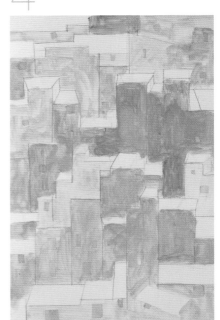

Ultramarine Blue ———

5. Use a pencil to draw the lines between the tiles of the rooftops.

5

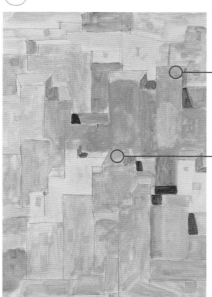

Burnt Sienna + Titanium White

Permanent Red + Titanium White

Ultramarine Blue + Ivory Black

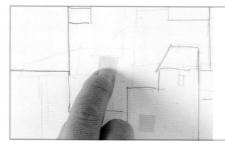

The pieces of adhesive tape that are used to mask parts of the painting should first be adhered and removed several times on another surface to reduce its adhesion so it will not damage the surface of the support when it is removed.

7

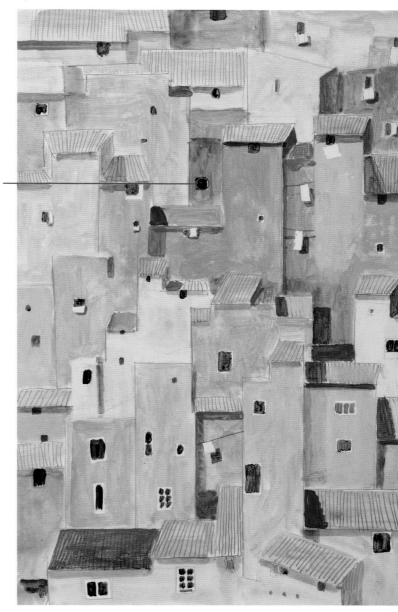

6. Remove the masks and paint the white squares with blue mixed with black. Leave some of the squares white to suggest hanging laundry.

6

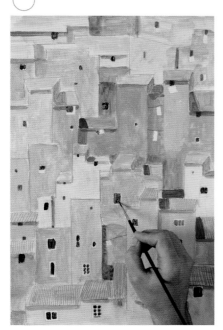

7. A few horizontal blue lines that suggest shadows on the façades help add relief to this effective representation of a city.

One typical aspect of graphic work is keeping the color within very defined shapes in the design. In this exercise, the landscape is carefully drawn, and the colors fill in the shapes of the drawing.

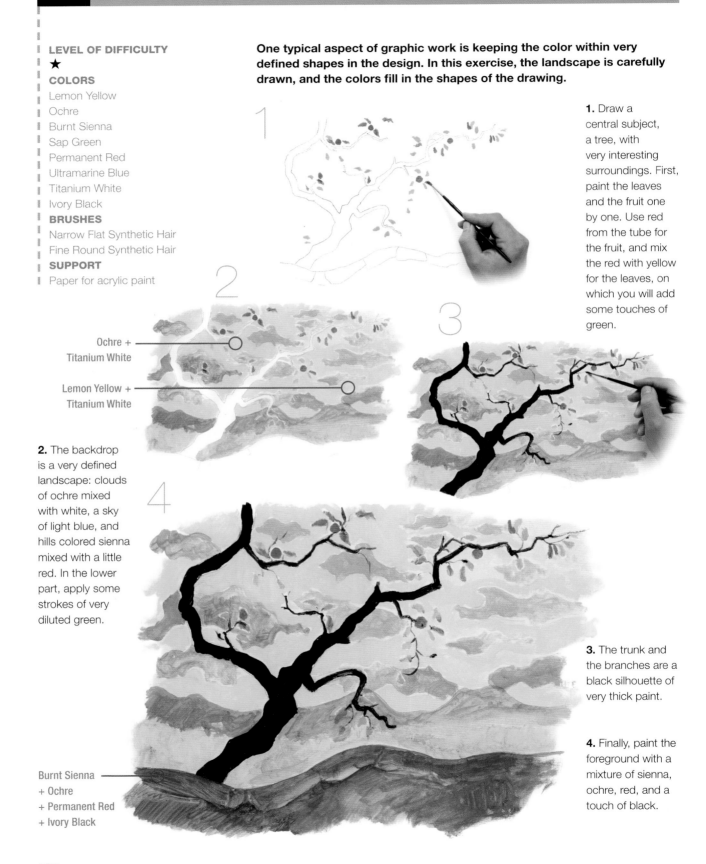

1. Draw a central subject, a tree, with very interesting surroundings. First, paint the leaves and the fruit one by one. Use red from the tube for the fruit, and mix the red with yellow for the leaves, on which you will add some touches of green.

Ochre + Titanium White

Lemon Yellow + Titanium White

2. The backdrop is a very defined landscape: clouds of ochre mixed with white, a sky of light blue, and hills colored sienna mixed with a little red. In the lower part, apply some strokes of very diluted green.

Burnt Sienna
+ Ochre
+ Permanent Red
+ Ivory Black

3. The trunk and the branches are a black silhouette of very thick paint.

4. Finally, paint the foreground with a mixture of sienna, ochre, red, and a touch of black.

LEVEL OF DIFFICULTY
★

COLORS
Ochre
Burnt Sienna
Titanium White
Ivory Black

BRUSHES
Wide Flat Synthetic Hair
Medium Round Synthetic Hair

SUPPORT
Paper for acrylic paint

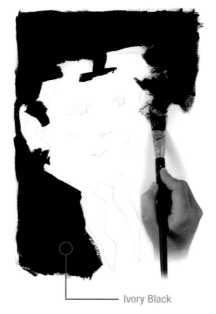

Ivory Black

Images on posters have traditionally showed a strong contrast. In the following example, you will take these contrasts to the maximum to achieve an attractive and dramatic effect based on the pure contrast of black and white.

1. Make a simple sketch; then paint a large black area around the lines of the face.

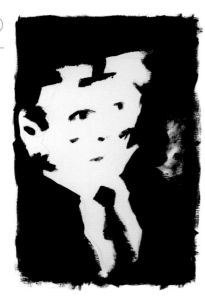

2. The black highlights characteristic details like the tie and some features of the face. At the right leave an area that is not completely covered, which will later represent the smoke from a pipe.

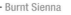

Burnt Sienna
+ Titanium White

3. Using an extremely diluted mixture of ochre and sienna, paint the face.

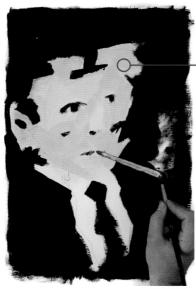

4. After making adjustments to the outline of the face, paint the pipe with a neutral gray.

LEVEL OF DIFFICULTY

★

COLORS

Lemon Yellow
Ochre
Burnt Sienna
Permanent Green
Permanent Red
Carmine
Ultramarine Blue
Titanium White
Ivory Black

BRUSHES

Narrow Flat Synthetic Hair
Fine Round Synthetic Hair

SUPPORT

Paper for acrylic paint

Graphic effects are created by stylization that isolates and emphasizes certain aspects of a subject as opposed to others. In the following landscape, you will put this principle into practice.

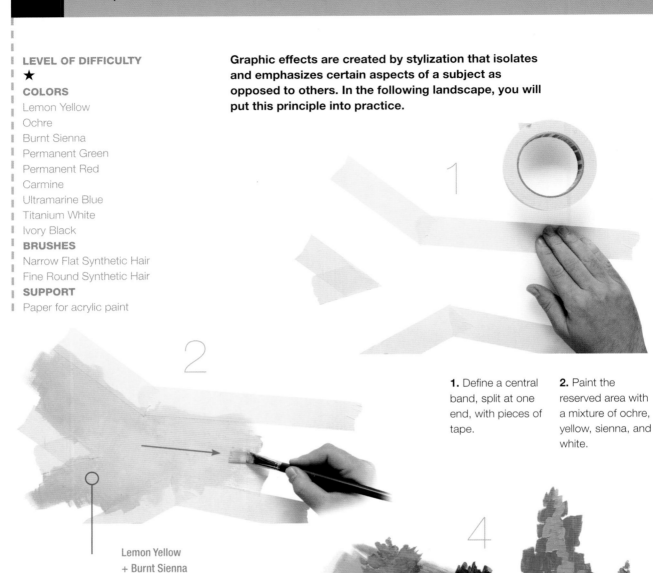

1. Define a central band, split at one end, with pieces of tape.

2. Paint the reserved area with a mixture of ochre, yellow, sienna, and white.

Lemon Yellow
+ Burnt Sienna
+ Titanium White

Permanent Green
+ Burnt Sienna
+ Ochre

3. Remove the pieces of tape and paint the previously covered areas with permanent green. Then use very thick red to paint the foliage of the trees.

4. Use very thick paint on the trees, leaving the brush marks. The different tones seen on the trees are the results of mixing carmine, blue, white, red, ochre, and green in different proportions.

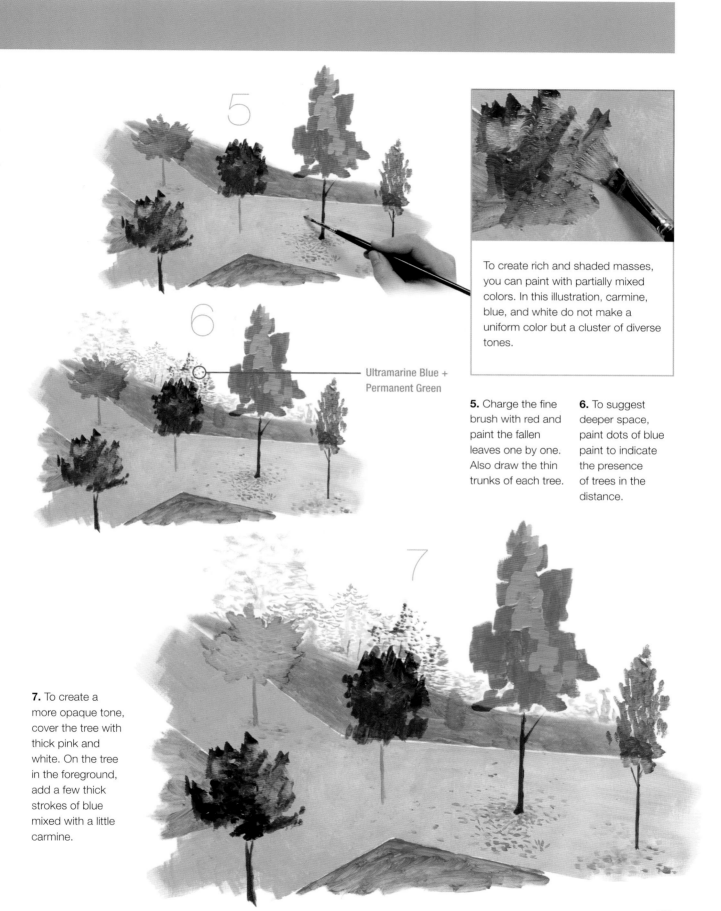

To create rich and shaded masses, you can paint with partially mixed colors. In this illustration, carmine, blue, and white do not make a uniform color but a cluster of diverse tones.

Ultramarine Blue + Permanent Green

5. Charge the fine brush with red and paint the fallen leaves one by one. Also draw the thin trunks of each tree.

6. To suggest deeper space, paint dots of blue paint to indicate the presence of trees in the distance.

7. To create a more opaque tone, cover the tree with thick pink and white. On the tree in the foreground, add a few thick strokes of blue mixed with a little carmine.

LEVEL OF DIFFICULTY
★
COLORS
Phthalo Blue
Carmine
APPLICATORS
Wide Flat Synthetic Hair
Palette Knife
SUPPORT
Paper for acrylic paint

Sgraffito becomes the protagonist of this exercise. It is a way of "drawing" with the handle of the brush, or with the edge of a palette knife, in recently applied paint.

1. Use a large amount of paint because you do not want the paint to dry too quickly. Use the brush to suggest the texture of the palm tree.

2. The handle of the brush creates lines in the paint to reveal the white of the support.

3. In this scene, the sgraffito drawing is as important as the texture made by the brush.

Phthalo Blue

4. Paint the background with a mixture of carmine and blue heavily diluted with water.

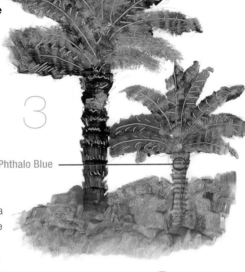

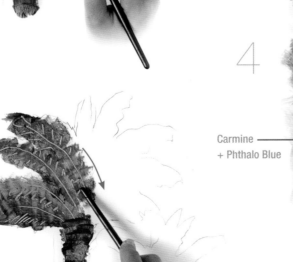

Carmine
+ Phthalo Blue

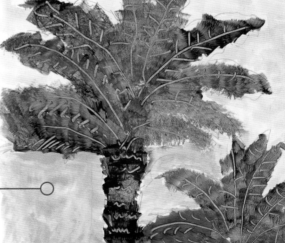

LEVEL OF DIFFICULTY
★

COLORS
Cadmium Yellow
Ochre
Permanent Red
Cobalt Blue
Sap Green
Titanium White
Ivory Black

BRUSHES
Medium Flat Synthetic Hair
Medium Round Hog Bristle

SUPPORT
Canvas Board

One common aspect of the graphic treatment using acrylic paint is the emphasis placed on the clarity of outlines. Here you will carefully follow the previously drawn areas and then redraw the silhouettes at the end of the process.

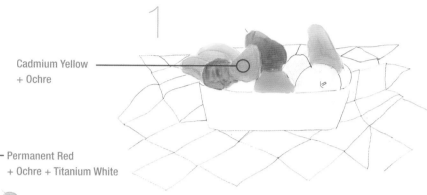

Cadmium Yellow + Ochre

Permanent Red + Ochre + Titanium White

1. Create a well-defined drawing with all the outlines so there will be no doubt about the placement of each color. The fruit with an ochre tone include some sienna mixed with white. The greens are made from sap green, ochre, and white.

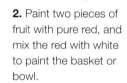

2. Paint two pieces of fruit with pure red, and mix the red with white to paint the basket or bowl.

3. The tablecloth is composed of red and white squares. The white ones are painted with a very light gray.

4. Go over some outlines with black to emphasize the graphic effect, and paint the background with a mixture of cobalt blue and a small amount of black.

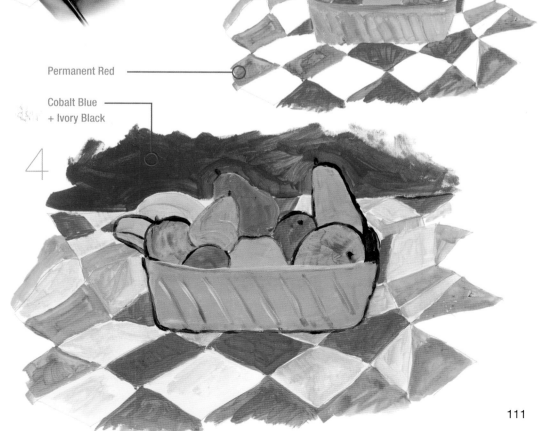

Permanent Red

Cobalt Blue + Ivory Black

LEVEL OF DIFFICULTY
★
COLORS
Sap Green
Burnt Sienna
Phthalo Blue
Ivory Black
BRUSH
Medium Round Hog Bristle
SUPPORT
Stretched Canvas

Heavily diluted acrylic paint can be used for drawing with a nib pen. In this watery scene, you will use this technique by combining a blurry background with the very hard precise lines of a nib pen.

1. Dampen the support with a wide brush charged with water before beginning the painting. Then apply a large area of blue paint with a very small amount of black.

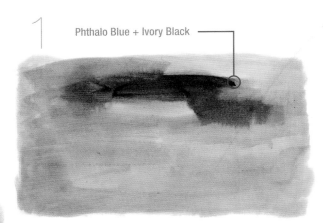

Phthalo Blue + Ivory Black

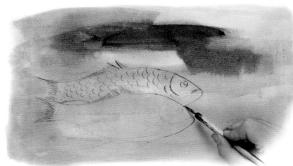

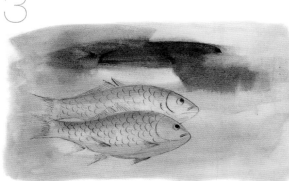

2. Draw the lines with pencil, and then go over them with a nib pen charged with a mixture of black and sienna.

3. When the lines have dried, paint the bodies of the fish with very diluted blue mixed with a little black.

4. To complete the scene, paint a few water lilies to suggest the plane of the surface of the water.

Sap Green

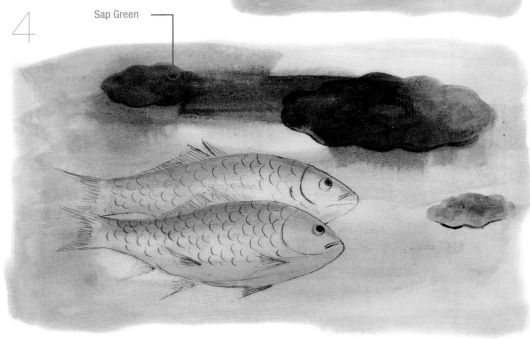

LEVEL OF DIFFICULTY
★
COLORS
Cadmium Yellow
Permanent Red
Permanent Green
Cobalt Blue
Titanium White
Ivory Black
BRUSH
Medium Round Hog Bristle
SUPPORT
Paper for acrylic paint

In this urban landscape, you will create a clear contrast between blocks of pure color that give the scene an ornamental feeling. All the figurative elements are drawn with heavy black lines, which you will then emphasize with patches of bright happy colors.

Cobalt Blue +
Titanium White

1. Attach several pieces of tape on the support to make reserves along the edges of some sides (but not all) of the patches of color.

Cadmium Yellow +
Permanent Red

2. Paint the warm colors below (yellow and yellow mixed with red), and the cool ones above (blue, blue lightened with white, and green).

3. Draw the buildings and the street in a very simple and daring manner, with wide simple lines.

Ivory Black

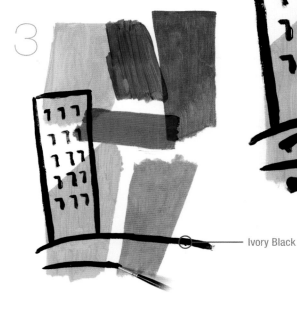

4. This technique is perfect for creating images that attract attention and are meant for communication or commercial purposes.

LEVEL OF DIFFICULTY
★
COLORS
Lemon Yellow
Ochre
Burnt Sienna
Permanent Red
Carmine
Permanent Green
Sap Green
Phthalo Blue
BRUSHES
Wide Flat Synthetic Hair
Medium Round Synthetic Hair
SUPPORT
Canvas Board

In this exercise, the paint is diluted with acrylic medium instead of with water. In this way, the paint acquires an extraordinary fluidity and transparency that makes it look like delicately colored gauze.

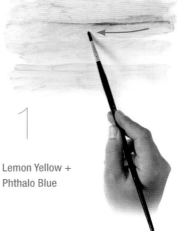

Lemon Yellow +
Phthalo Blue

1. Before painting, spread acrylic medium mixed with water on the support. Then paint some red lines, which will turn pink as they are diluted in the acrylic medium. Also paint some blue and yellow lines.

2. Spread acrylic medium on the board as you continue painting. Layer red and carmine brushstrokes to create a pearly texture.

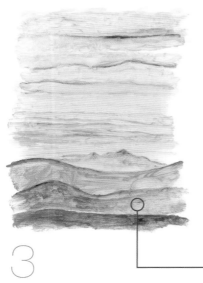

Sap Green +
Phthalo Blue

3. Paint the mountains the same way you did the sky, using a mixture of phthalo blue with a tiny bit of carmine. In the foreground, apply ochre mixed with green.

4. Paint the trunks of the trees with a mixture of blue and sienna. The leaves were also painted with burnt sienna.

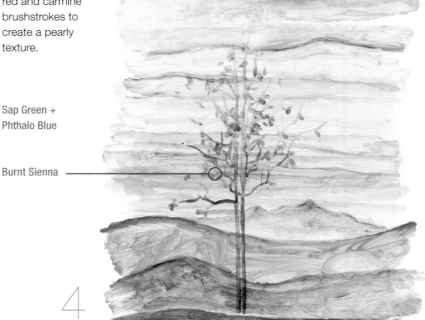

Burnt Sienna

LEVEL OF DIFFICULTY
★
COLORS
Ochre
Burnt Sienna
Permanent Red
Permanent Green
Sap Green
Ultramarine Blue
Titanium White
BRUSH
Medium Round Synthetic Hair
SUPPORT
Stretched Canvas

You are already familiar with masking fluid. In this exercise, you will use it for limiting and separating the planes and zones in the landscape to create an effect that is similar to leaded glass.

1. Paint the masking fluid over the lines of the preliminary drawing. Allow them to dry and then paint over them again.

Sap Green + Ultramarine Blue — Permanent Green —

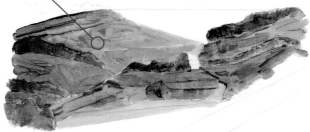

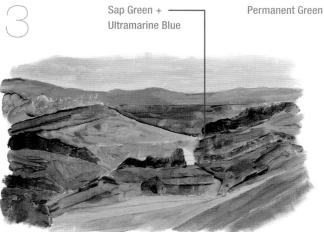

2. Combine permanent green and sap green for the fields. On the margins work with those greens mixed in different proportions with sienna.

3. Use a mixture of ochre and sienna in the foreground. For the sea, use pure ultramarine blue, and paint the mountains a mixture of blue and red.

4. This is how it looks after removing all the masking fluid. Finally, paint the sky with blue lightened with white.

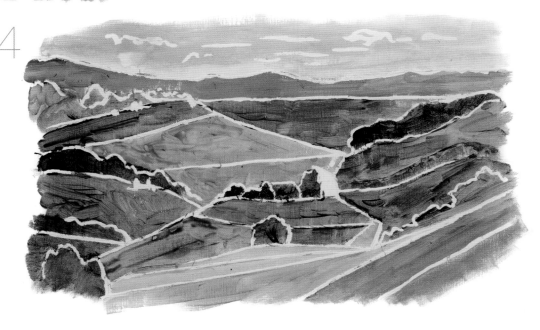

LEVEL OF DIFFICULTY
★ ★

COLORS
Cadmium Yellow
Ochre
Burnt Sienna
Carmine
Permanent Red
Permanent Green
Sap Green
Ultramarine Blue
Titanium White
Ivory Black

BRUSHES
Medium Flat Synthetic Hair
Medium Round Synthetic Hair

SUPPORT
Stretched Canvas

In this exercise and the following one, you will be working with the same subject to explore all the artistic approaches to transparencies, with the brush mark, the brushstroke, and the line. You will also be using masking fluid to preserve some delicate details.

1. The preliminary drawing is important, although it will not help to be very precise because it may interfere with the freedom of the brushstrokes.

Cadmium Yellow +
Burnt Sienna

2. Apply some areas of light colors with warm tendencies: oranges (mixed from red and yellow), light earth tones (sienna, ochre, and white), and light greens (sap green, ochre, and white).

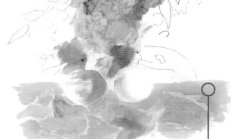

Carmine +
Titanium White

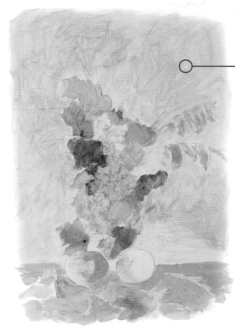

Ultramarine Blue +
Titanium White

3. Continue adding some light colors. Now use carmine lightened with white and the ochres. Make sure all the brush marks are visible to guarantee the final effect.

4. The ultramarine blue on the background adds a necessary cool contrast to the dominant warm tones. At this moment all the colors are transparent.

5. Add thicker color, beginning with a mixture of sienna and blue.

Burnt Sienna
+ Ultramarine Blue

The liquid mask is not only used to mask lines, but also areas that are small. Here we have reserved all the daisies in the bunch.

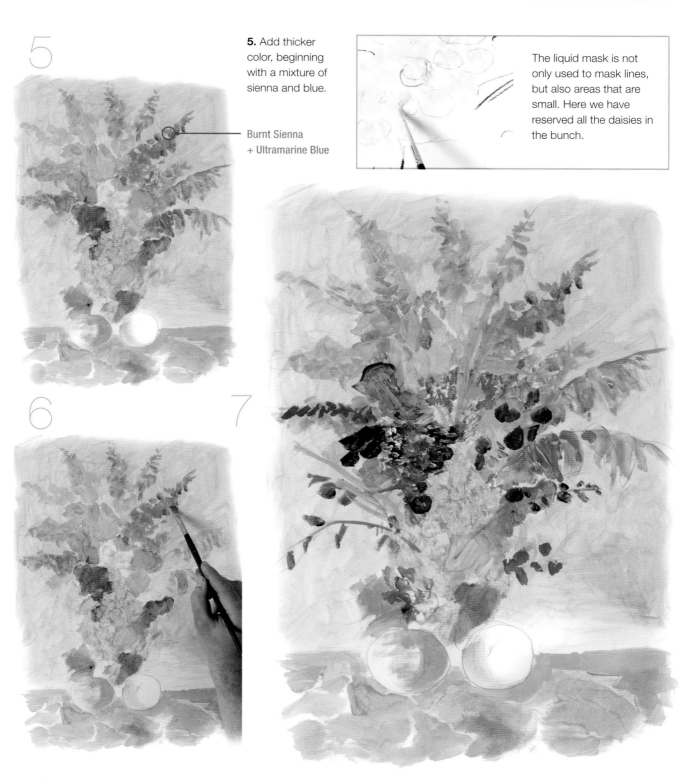

6. Here you see the density and thickness of the orange brushstrokes on the upper stems, in contrast to the fluid appearance of the rest.

7. Now you can apply undiluted paint so that the tones are much denser and darker, especially those that have a mixture of green and sienna.

LEVEL OF DIFFICULTY
★ ★

COLORS
Cadmium Yellow
Ochre
Burnt Sienna
Carmine
Permanent Red
Permanent Green
Sap Green
Ultramarine Blue
Titanium White
Ivory Black

BRUSHES
Medium Flat Synthetic Hair
Medium Round Synthetic Hair

SUPPORT
Stretched Canvas

The artistic value of this painting owes more to the technique that was used than to the subject itself. The multiple transparent textures are now combined with opaque applications of thick paint and visible brush marks to create a vibrant and opulent effect.

1. The thick dark paint intensifies the contrasts and relief in the motif.

2. Apply a mixture of yellow and ochre to add density to the fruit.

Permanent Green + Burnt Sienna

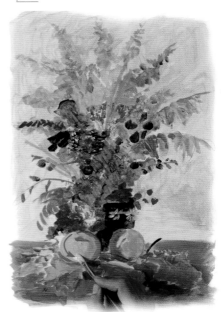

Ultramarine Blue + Titanium White

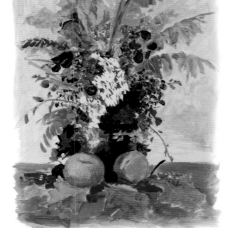

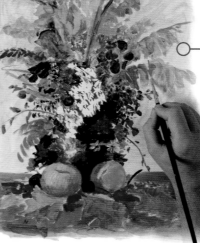

3. The daisies reserved in white add a delicate touch that contrasts with the energy of the painting technique.

4. Use a mixture of blue and white to "cut out" the outlines of the leaves, covering the paint that confuses their edges.

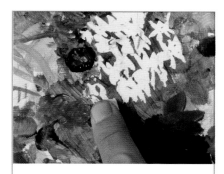

The masking fluid is removed when the paint is completely dry. It will easily come off when rubbed with a finger. It is important to remove all traces of the liquid gum before continuing with the painting.

5. Retouch the daisies by adding small yellow dots in their centers.

6. The colorist and Baroque effect in the painting comes from the play of the many opaque and transparent textures.

5

Sap Green +
Ultramarine Blue

6

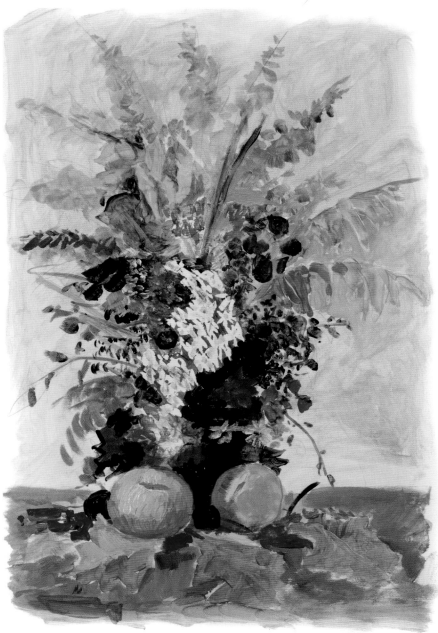

LEVEL OF DIFFICULTY

★

COLORS

Cadmium Yellow

Ochre

Burnt Sienna

Cobalt Blue

Titanium White

BRUSHES

Medium Flat Synthetic Hair

Fine Round Synthetic Hair

SUPPORT

Canvas Board

This time you will use the masking fluid to protect the colors of details you have already painted to achieve a more direct and natural effect. This helps you avoid painting around all the outlines of the shapes with the background color.

1. Paint the ears of wheat with a mixture of ochre and cadmium yellow. The shapes of the brush marks indicate the grains and texture of the ears.

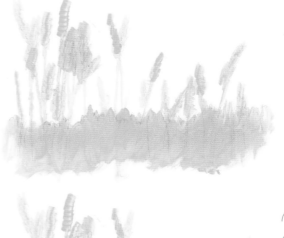

Cobalt Blue +
Titanium White

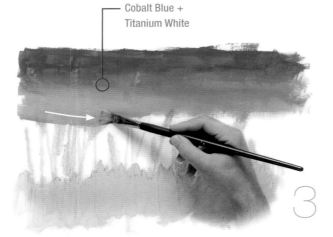

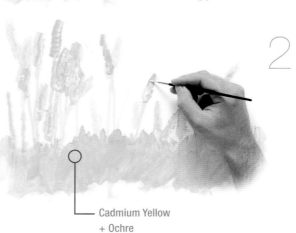

Cadmium Yellow
+ Ochre

2. Apply the masking fluid over each ear, carefully following its outline.

3. After the masking fluid has dried, apply a large area of cobalt blue, increasingly mixed with white as you move toward the lower part of the sky.

4. When the paint is completely dry, remove the masking fluid by rubbing it. The final effect is intense and very bright: the ears look like they were painted on top of the blue background.

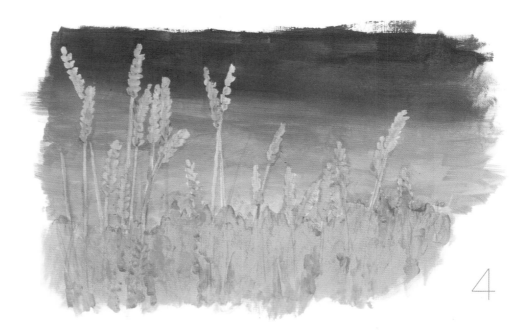

LEVEL OF DIFFICULTY
★
COLORS
Phthalo Blue
Titanium White
Ivory Black
BRUSHES
Medium Flat Synthetic Hair
Medium Round Hog Bristle
SUPPORT
Paper for acrylic paint

Acrylic allows you to preserve the strength and color of the paint, even when you are working quickly and expressively. In this equestrian scene, you will apply such a treatment in monochromatic blues.

1. After drawing the galloping horse, paint the support with vigorous blue brushstrokes, with paint that is quite thick.

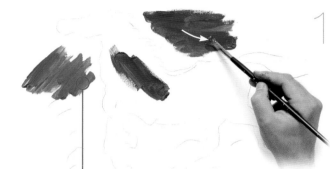

Phthalo Blue
+ Titanium White
+ Ivory Black

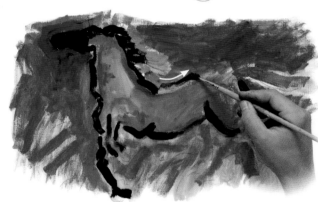

2. The brushstroke must transmit all the energy that flows from each movement of the hand.

3. Draw the outline of the horse with black, using thick, unhesitating brushstrokes.

4. Add a few white brushstrokes at the bottom to suggest water splashing as the horse runs through it.

Titanium White
+ Phthalo Blue

LEVEL OF DIFFICULTY
★

COLORS
Cadmium Yellow
Ochre
Burnt Sienna
Permanent Green
Sap Green

BRUSHES
Wide Flat Synthetic Hair
Medium Flat Synthetic Hair
Fine Round Synthetic Hair

SUPPORT
Stretched Canvas

Not all accidents should be rejected. You can provoke some of them and use them to your favor. Dripped and running liquid paint can form interesting and artistic effects that add a poetic and painterly representation to a common subject.

Burnt Sienna
+ Cadmium Yellow

1. To create this base color, use a wide brush and apply diluted paint over another color without completely mixing them. Use ochre, yellow, and sienna.

Burnt Sienna

2. Take a brush that is very full of paint, and wring it over the support by squeezing the hair with your fingers. Use sienna and ochre mixed with sienna and white.

3. Add drips of permanent green and partially absorb the paint with a paper towel.

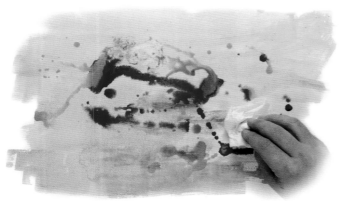

Burnt Sienna
+ Ochre

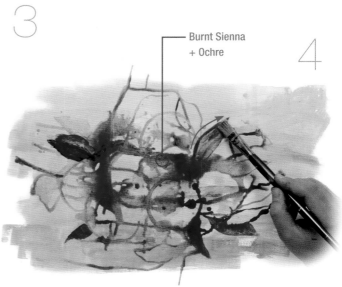

4. Tip the support in several directions so the small pools of paint will run. Among these marks, paint the silhouettes of some leaves and some circles to suggest fruit.

5. This cluster of lines and marks looks like a randomly created group of fruit and leaves, with minimal intervention on the part of the artist.

Acrylic paint heavily diluted in water will form pools on the support. You can dry these small puddles with absorbent paper, or allow the liquid to flow over the surface and leave drip marks.

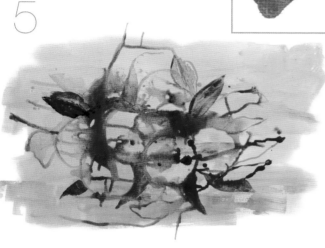

Permanent Green + Sap Green

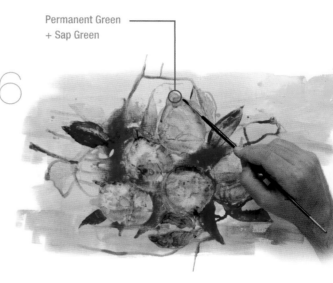

6. Apply large areas of very diluted permanent green and then partially absorb it with paper. Retouch the outlines with sap green so they look like pears.

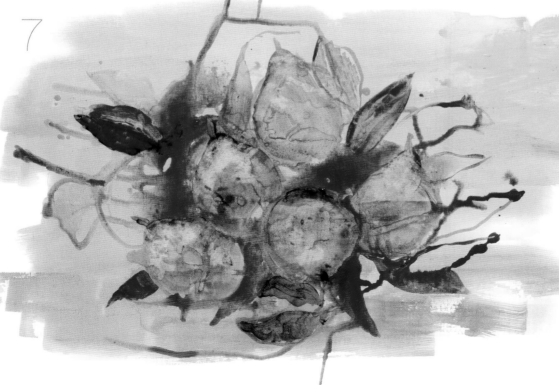

7. The result is quite suggestive. This technique is wide open to experimentation and exploration with the artistic potential of acrylic paint.

LEVEL OF DIFFICULTY
★ ★
COLORS
Burnt Sienna
Burnt Umber
Carmine
Titanium White
Ivory Black
BRUSH
Medium Flat Synthetic Hair
SUPPORT
Canvas Board

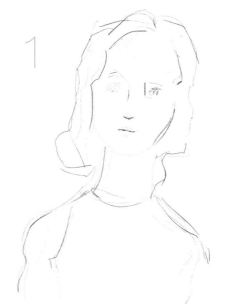

Energy and courage in artistic approaches are always more difficult in figures and portraits. But if you are able to ignore your instinctive respect for the human form, you can create some highly expressive, even expressionistic, results.

1. The preliminary drawing is important, since it is the only objective basis for this concise and expressionistic treatment.

Burnt Umber

2. First paint the shadows of the body and head with burnt umber. Work quickly and decisively.

3. The flesh tones will be a mixture of sienna, burnt umber, and white. Add a little black to the mixture for the middle tones.

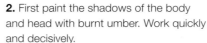

Burnt Sienna
+ Burnt Umber
+ Titanium White

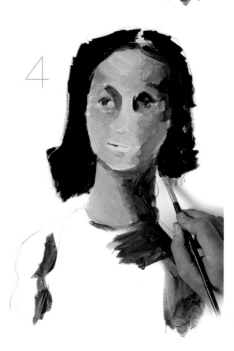

The contrasts between transparent shadows and opaque light are always very interesting artistically. Here, the burnt umber becomes transparent when mixed with water.

4. Paint the hair with black, occasionally mixed with a little burnt umber. As you work, dare to apply some brushstrokes out of place.

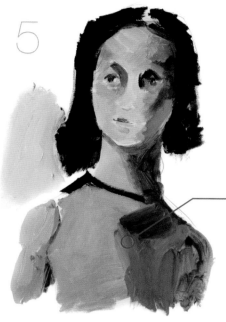

5. Use neutral grays (black mixed with white) of different shades for the body, the arms, and the background.

6. After painting the background, add a few strokes of gray on the hair and light touches of carmine on the lips.

Titanium White + Ivory Black

Titanium White + Ivory Black

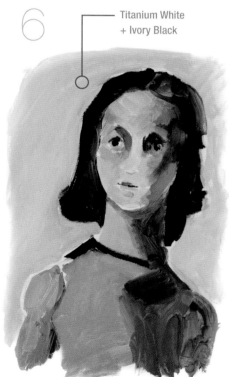

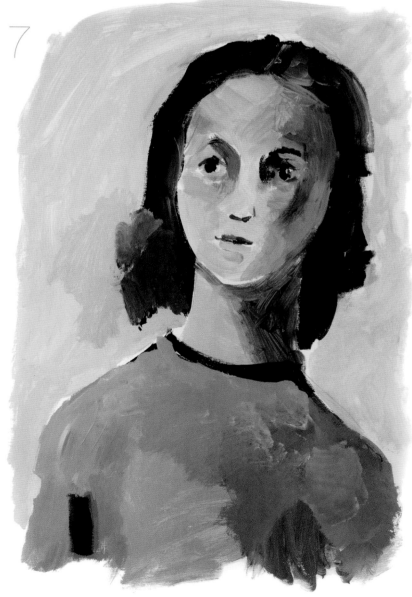

7. Some of the brushstrokes look chaotic; however, the strength and expressiveness of this style overcome any other consideration.

LEVEL OF DIFFICULTY
★
COLORS
Lemon Yellow
Burnt Sienna
Ochre
Permanent Green
Titanium White
BRUSH
Medium Flat Synthetic Hair
SUPPORT
Canvas Board

It is not common to use acrylics when painting outdoors; however, you can make sketches and color notes by reducing your equipment to just the indispensable minimum.

Lemon Yellow
+ Burnt Sienna

1. Draw the subject in pencil quickly and concisely, which is habitual when working outdoors. Quickly paint the body of the cow with a mixture of ochre and sienna.

2. After covering the whole body with the mixed colors, use pure sienna to darken the shadows and emphasize the volume.

Permanent Green
+ Burnt Sienna
+ Lemon Yellow

Permanent Green
+ Burnt Sienna

3. Lighten the most illuminated parts of the animal with a mixture of sienna and white, and then paint the grass with green and a little sienna.

4. The color of the background is a mixture of green and sienna heavily diluted with water.

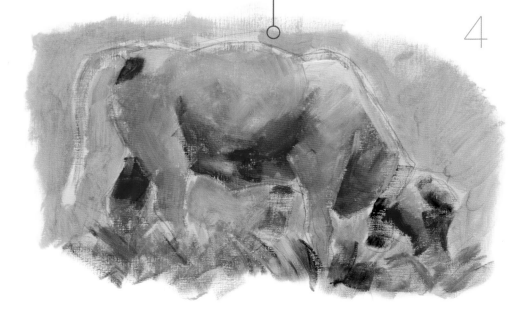

LEVEL OF DIFFICULTY
★ ★

COLORS
Sap Green
Ultramarine Blue
Titanium White
Ivory Black

BRUSH
Medium Flat Synthetic Hair

SUPPORT
Stretched Canvas

The wet ground and generally damp atmosphere is a common effect in watercolor painting. But you can also achieve a similar artistic effect with acrylic paint.

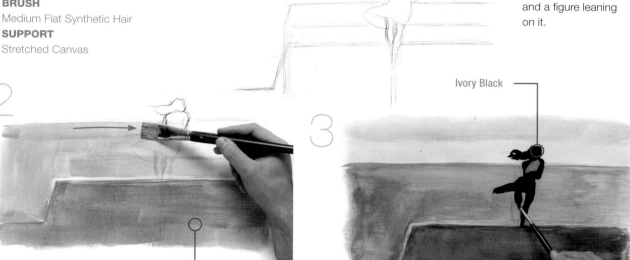

1. Draw a railing across the horizon and a figure leaning on it.

Ivory Black

Ultramarine Blue + Sap Green + Ivory Black + Titanium White

2. Paint the area of the ground and the sea with a mixture of ultramarine blue, sap green, and black. For the sea, use heavily diluted paint, which will therefore be lighter.

3. The figure is just a silhouette that you can paint with black and a little white to create a gray tone.

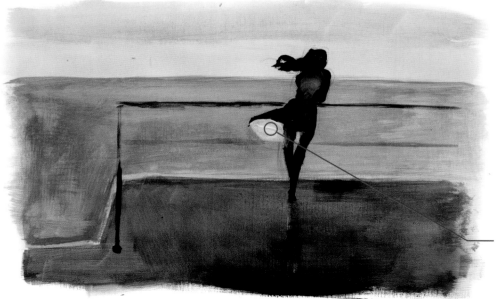

4. Add a new blue gray layer to the pavement and on it paint a vertical black brushstroke. Go back over it with the brush, blurring it to create the effect of a reflection on the wet ground.

Titanium White

LEVEL OF DIFFICULTY

★

COLORS

Burnt Sienna

Carmine

Titanium White

Ivory Black

APPLICATORS

Medium Round Synthetic Hair

Palette Knife

SUPPORT

Canvas Board

When you spread acrylics with a palette knife, smoothing and dragging the paint over the support, it is distributed in an irregular manner. In the following exercise, you will work on a background of color that will play a part in the color and texture of an olive tree.

1. Spread a layer of carmine with the palette knife. The color should cover the support, but with a thin enough layer that the white of the board shows through.

Burnt Sienna

Titanium White + Ivory Black

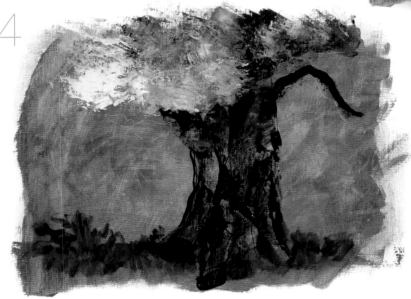

2. When the background is dry, apply black in the irregular shape of an olive tree. Allow the paint to accumulate in some areas and scrape it in others.

3. Paint white and black on the branches, and mix them directly on the support to create a broken and irregular effect.

4. Paint a few bits of grass and shoots with the brush, using a mixture of carmine and a bit of black to indicate the ground below the olive tree.

LEVEL OF DIFFICULTY
★
COLORS
Titanium White
Wax Crayons
APPLICATOR
Palette Knife
SUPPORT
Paper for acrylic paint

You will not use brushes in this exercise. It is done completely with a palette knife and colored wax crayons. The crayons will not accept the watery paint, and when it has dried, it can be removed in the areas where there is a line or area of wax. This is a festive painting, ideal for doing with children.

1. Paint a series of fruits with the wax crayons that are much like those used by school children.

2. When the drawings are covered with white dragged by the palette knife, some traces of wax tint the paint.

3. After the layer of acrylic paint is dry, scrape across the fruit with the edge of the palette knife.

4. The result is loose, simple, and very colorful.

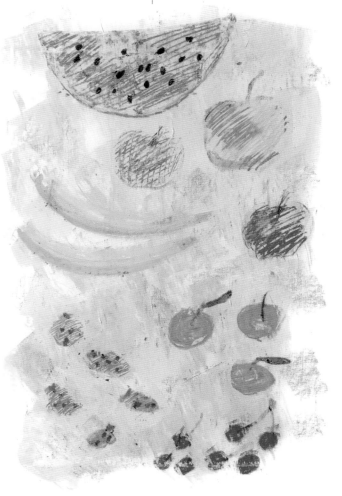

LEVEL OF DIFFICULTY
★ ★

COLORS
Cadmium Yellow
Ochre
Permanent Red
Sap Green
Phthalo Blue
Titanium White
Ivory Black

APPLICATORS
Wide Flat Synthetic Hair
Palette Knife

SUPPORT
Stretched Canvas

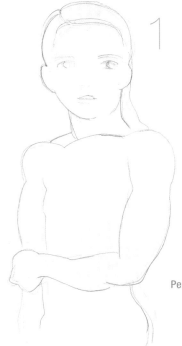

Sometimes the crudest means are best for achieving delicate results. In this exercise, you will use a palette knife (with a square end) to achieve the effect of the skin of a young girl.

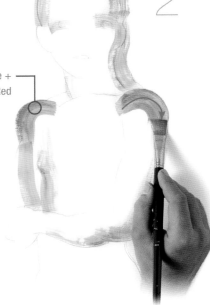

Ochre +
Permanent Red

1. Here the drawing is essential, since you will need to use it after applying the color with the palette knife so that the paint does not break up the form.

Cadmium Yellow

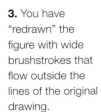

2. Go over some lines of the drawing with wide brushstrokes of ochre and red that are only partially mixed. The paint should be quite fluid so that the brush glides easily across the support.

Ochre +
Titanium White

3. You have "redrawn" the figure with wide brushstrokes that flow outside the lines of the original drawing.

4. Cover the trunk and the arms with wide strokes of ochre mixed with white, using the palette knife. It is acceptable, and even better, if this color mixes with the previous ones.

The palette knife mixes the colors as you apply them. It is not necessary to mix two or more colors beforehand; instead, just apply one after another to the support and then mix them as you work with the palette knife.

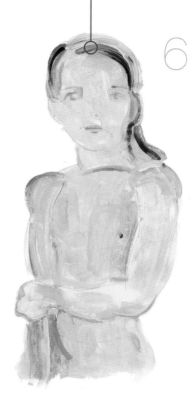

Sap Green

Permanent Red

5. Use pink (red and white) on the face and neck instead of the ochre used on the rest of the body. The similarity between the two colors allows them to integrate well.

6. With the round brush, add some grays (mixed from black and white) to the shoulder and green, blue, and purple (blue mixed with red) brushstrokes on the hair.

7. Finally, go over some of the drawn lines, which are still visible, with a stroke of pink to add some anatomical strength to the work.

LEVEL OF DIFFICULTY
★ ★
COLORS
Ochre
Carmine
Burnt Sienna
Titanium White
Ivory Black
APPLICATORS
Fine Round Synthetic Hair
Palette Knife
SUPPORT
Stretched Canvas

Some subjects are ideal for painting with a palette knife. In this case, the distribution of colors, the shapes of the feathers, and the outline of the rooster can all be rendered quite easily if the artist has a certain amount of experience.

1. Make a preliminary drawing of the bird; then spread a mixture of ochre and a small amount of carmine across the surface of its body.

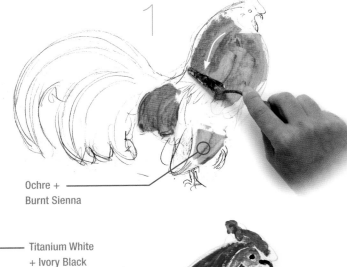

Ochre +
Burnt Sienna

2. Use gray and black to make the curved feathers of the tail.

Titanium White
+ Ivory Black

Burnt Sienna
+ Carmine

3. Use a brush to apply long strokes of carmine and black to represent the fringe of feathers that extends across the entire body of the rooster. Then paint the bird's crest with pure carmine.

4. To finish the painting, indicate the ground with a mixture of ochre and gray.

LEVEL OF DIFFICULTY
★ ★
COLORS
Ochre
Carmine
Burnt Sienna
Cobalt Blue
Titanium White
APPLICATORS
Fine Round Synthetic Hair
Palette Knife
SUPPORT
Paper for acrylic paint

The palette knife is not for making fine details nor gradual shading of colors; you must work with masses of paint. This characteristic is evident in the following exercise, where we render a figure using contrasting masses of color.

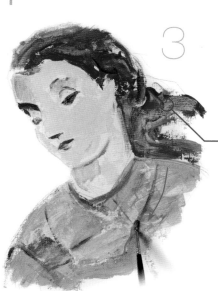

Carmine +
Titanium White

Burnt Sienna +
Carmine

Cobalt Blue

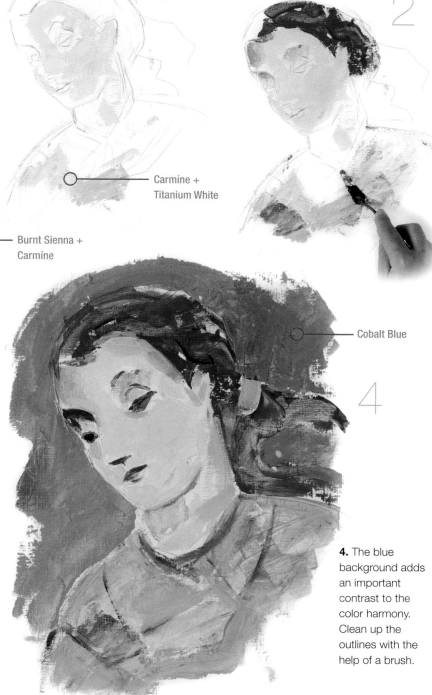

1. Since it is not possible to accurately fill in the outlines when working with a palette knife, apply pink paint (carmine and white) as well as you possibly can.

2. Paint the hair with sienna. Then, with some of this color still on the palette knife, add color to the previously painted pink.

3. Paint the dress with ochre and draw some gray lines on it (ochre, black, and white) to simply indicate the shape.

4. The blue background adds an important contrast to the color harmony. Clean up the outlines with the help of a brush.

LEVEL OF DIFFICULTY

★

COLORS

Magenta

Permanent Red

Permanent Green

Sap Green

Cobalt Blue

Titanium White

Ivory Black

APPLICATORS

Medium Flat Synthetic Hair

Palette Knife

SUPPORT

Stretched Canvas

The aggressive effect of bright, saturated colors is a characteristic of cityscapes. Here you will address the many visual stimuli that assault us when contemplating the big city.

1. Use a square palette knife to distribute large amounts of pure magenta paint, as well as an amount of permanent green.

Magenta + Titanium White

2. Alternate the greens (permanent green and sap green) by mixing them with a small amount of blue. The grays will appear where the green mixes with the magenta.

Permanent Green

Permanent Red + Cobalt Blue

3. Some kind of figurative detail is needed to localize the scene. This exterior urban scene is identified with a blue palm tree that is painted with a brush.

4. Another palm tree is painted with a mixture of red and blue, a large traffic light and the gray of the street complete the allusions to the urban environment.

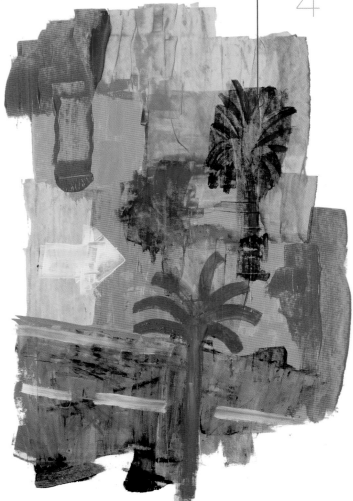

134

LEVEL OF DIFFICULTY
★

COLORS
Cadmium Yellow
Permanent Red
Magenta
Permanent Green
Ultramarine Blue
Titanium White
Ivory Black

APPLICATORS
Wide Flat Synthetic Hair
Palette Knife

SUPPORT
Paper for acrylic paint

1. Paint some large uniform areas of bright colors: red, yellow, orange, green, magenta, and blue.

Permanent Green
+ Ultramarine Blue
+ Titanium White

Next we will look at a simple technique that invites experimentation. At the same time, this exercise is ideal for learning to investigate color and its many effects.

Titanium White
+ Ivory Black

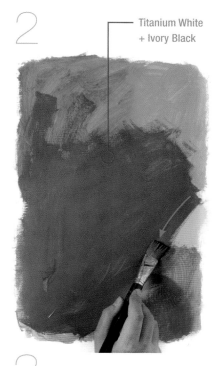

2. When the paint is dry, paint a layer of gray (mixed from white and black) over them.

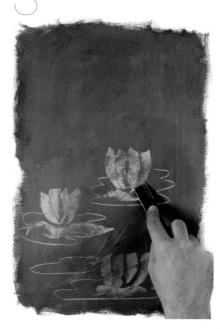

3. Use the edge of the palette knife to draw the shapes of the water lilies in the gray paint before it dries.

4. The results will vary depending on the colors used for the background. In any case, it is a good idea to use a neutral color for the top layer

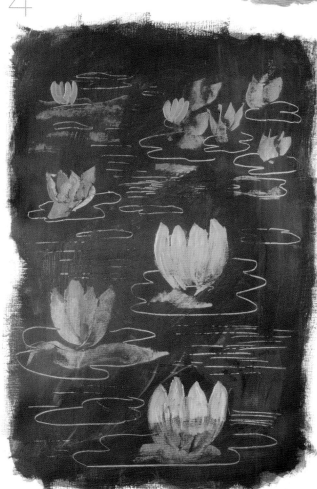

LEVEL OF DIFFICULTY

★

COLORS

Ochre

Burnt Sienna

Permanent Red

Ultramarine Blue

Titanium White

Ivory Black

BRUSH

Wide Flat Synthetic Hair

SUPPORT

Stretched Canvas

Marble sand (or marble dust if it is finely ground) is a filler that, when added to acrylic medium, can be used to prepare supports with a thick layer of texture. It is almost like painting on a very rough wall.

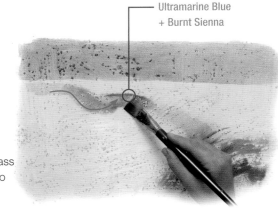

Ultramarine Blue + Burnt Sienna

1. Paint a blue band for the sky, and with the same paint mixed with a little sienna paint the beach.

2. Draw diagonal lines with the brush to suggest grass on the dunes. Also apply some red on the horizon to indicate the roof of a house. Paint the center of the composition with ochre.

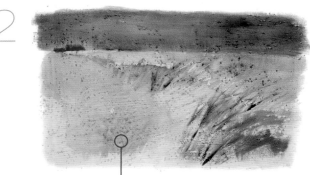

Ultramarine Blue + Ochre

3. Moving the brush in this manner will create an effect in the painting that emphasizes the presence of sand, which is also suggested by the texture of the support.

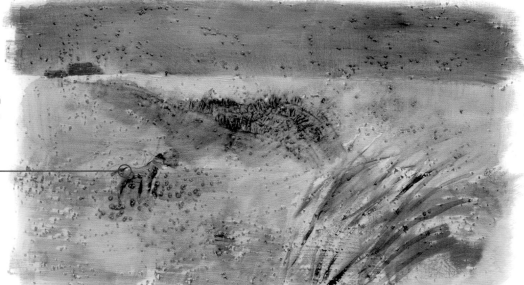

Ultramarine Blue

4. Place a dog in the center of the dunes to give an idea of the relative sizes and distances in the composition.

LEVEL OF DIFFICULTY
★

COLORS
Ochre
Burnt Sienna
Permanent Green
Ultramarine Blue
Titanium White
Ivory Black

BRUSH
Large Round Hog Bristle

SUPPORT
Stretched Canvas

Ground or chopped cork is an alternative to the mineral fillers. It is much lighter and is not as damaging to the paintbrushes that have to paint over the texture it creates. Mix the cork with acrylic medium to prepare the support.

1. Draw a crab and some shells on what will be a rocky shore. Paint with a mixture of blue, black, and green, leaving unpainted "islands" that will be covered with ochre.

2. Use a mixture of sienna, ochre, and black to paint the body of the crab. This same color, in different proportions, will be used for the rest of the details.

Ultramarine Blue +
Permanent Green

Burnt Sienna
+ Ochre
+ Ivory Black

3. Continue darkening the color of the sea by adding new layers of blue mixed with green.

4. The finish is rough, crude, and very uneven, just like the rocky shores where these small crustaceans are found.

LEVEL OF DIFFICULTY
★ ★

COLORS
Cadmium Yellow
Ochre
Burnt Sienna
Carmine
Ultramarine Blue
Titanium White
Ivory Black

BRUSHES
Large Round Hog Bristle
Fine Round Synthetic Hair
Very Fine Round Synthetic Hair

SUPPORT
Stretched Canvas

Pumice is a fine rough powder that is obtained from grinding pumice stone. Agglutinated with different proportions of acrylic medium, it makes bases with a light texture that is very evident when painted.

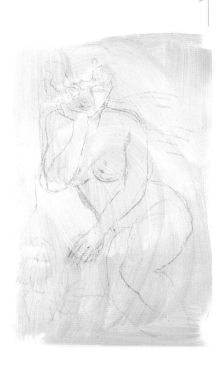

Ultramarine Blue

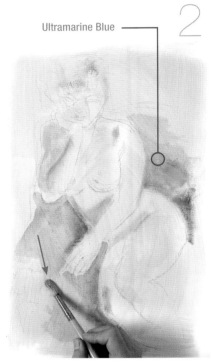

Carmine +
Ultramarine Blue

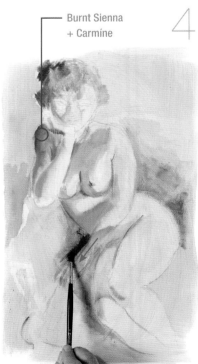

Burnt Sienna
+ Carmine

1. You will notice the presence of the textured background when making the preliminary drawing. The pumice makes a surface that is similar to sandpaper with a gray tone.

2. Paint some flesh tones with a mixture of sienna, ochre, and white, and spread some blue paint around the outside of the figure with a large amount of water.

3. Add heavily diluted carmine and sienna in the shadows: the hair is yellow and ochre in the lighted areas and sienna in the shadows.

4. Continue to darken the shaded zones with blues and mixtures of blue and carmine. The texture of the support causes the shadows to lose their definition and makes them richer and denser.

5. Interestingly, working on a base textured with pumice is reminiscent of watercolor painting: the colors are very sweet, and they slightly blend with each other.

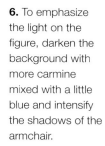

6. To emphasize the light on the figure, darken the background with more carmine mixed with a little blue and intensify the shadows of the armchair.

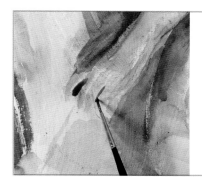

Although the treatment of the work is not very detailed, it is a good idea to incorporate carefully drawn small details and minutia to make the painting more interesting.

7. The figure shows a high level of finish, but it has areas that are suggestively undefined thanks to the roughness of the support, which resists a high level of detail.

Burnt Sienna

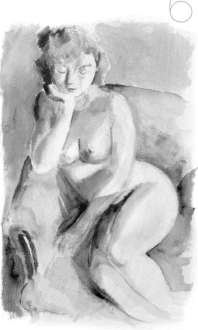

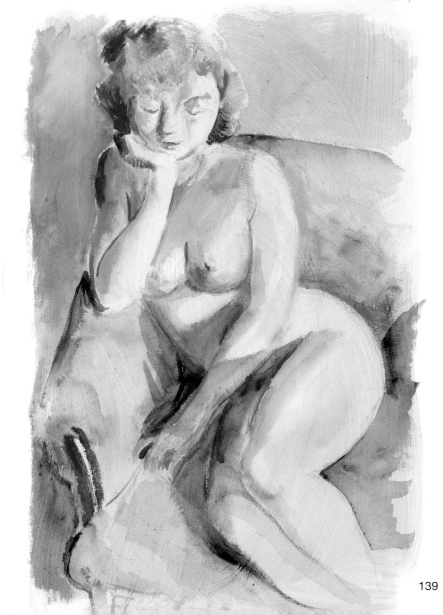

LEVEL OF DIFFICULTY
★
COLORS
Ochre
Permanent Red
Ultramarine Blue
Titanium White
BRUSH
Wide Flat Synthetic Hair
SUPPORT
Stretched Canvas

Canvases are sold with a coat of primer already applied, or the artist can prime them unless he or she prefers to work directly on raw canvas like you will be doing in this exercise. This is an extremely absorbent support, but this characteristic can be used in favor of the painting.

1. The fabric absorbs paint very quickly, so you will have to go over each area repeatedly with diluted paint. Use a mixture of red and blue diluted with water.

2. The thicker colors, like the pink on the dipper, have a very different texture from the diluted colors, like the mauve and pinks in the background.

3. Paint the pitcher with a lot of water and a large amount of paint to ensure that the color is not as washed out as the colors in the background.

1

2

Permanent Red
+ Ultramarine Blue
+ Titanium White

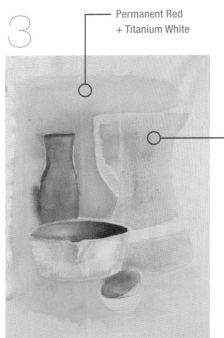

3

Permanent Red
+ Titanium White

Ochre

4

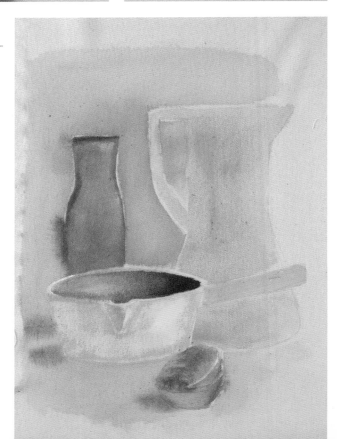

4. Everything seems immersed in fog when painted on raw canvas. Use thick, undiluted paint to create more precise outlines.

LEVEL OF DIFFICULTY
★

COLORS
Burnt Sienna
Ultramarine Blue
Titanium White

BRUSH
Wide Flat Synthetic Hair

SUPPORT
Paper for acrylic paint

Transparent medium is a liquid that can be mixed with acrylic paint to increase its transparency. Here you will use it to paint the back of a female figure with the delicacy that is typical of a watercolor.

Burnt Sienna + Titanium White

Burnt Sienna + Ultramarine Blue

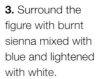

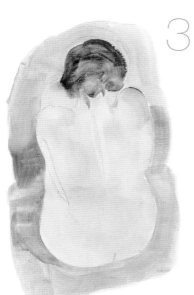

Burnt Sienna

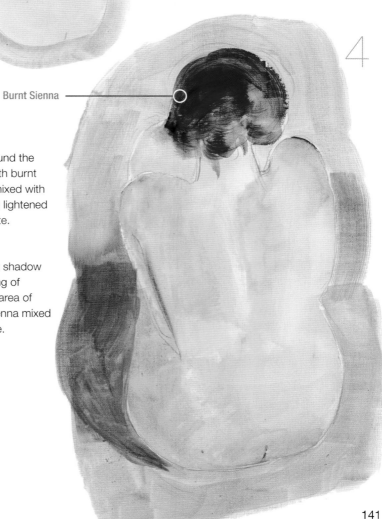

3. Surround the figure with burnt sienna mixed with blue and lightened with white.

1. Paint within the lines of the drawing with burnt sienna mixed with transparent medium. Make the left side of the figure a bit darker.

2. This looks like a watercolor because of the amount of transparency achieved with the medium.

4. Add a shadow consisting of another area of burnt sienna mixed with blue.

LEVEL OF DIFFICULTY
★

COLORS
Burnt Sienna
Permanent Red
Ochre
Phthalo Blue
Titanium White
Ivory Black

BRUSH
Wide Flat Synthetic Hair

SUPPORT
Paper for acrylic paint

Casein is a milk protein. It is used, among other things, for making various products for painters. In this exercise, you will use casein powder mixed with water to prepare the support and create a base that is very absorbent and at the same time smooth.

1. Apply a mixture of ochre and sienna over the initial drawing. The brushstrokes will be quickly absorbed, but they will easily color the background to create a glaze of soft, suggestive color.

Ochre + Burnt Sienna

2. Begin by painting the decorative motif, the leaves of the paints, with phthalo blue.

Phthalo Blue

3. Add some of the flowers, first with sienna and then with a fairly thick permanent red mixed with white.

4. Paint the small bird with solid black to compensate for the different transparencies and glazes in the design.

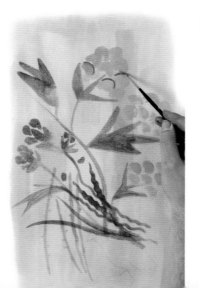

Burnt Sienna + Permanent Red

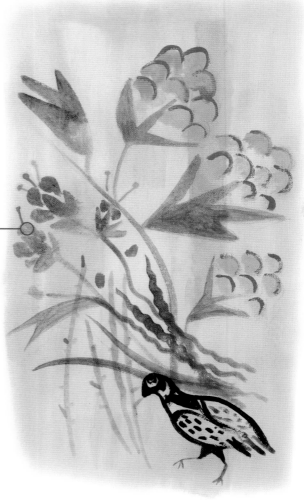

LEVEL OF DIFFICULTY
★
COLORS
Cadmium Yellow
Permanent Red
Magenta
Permanent Green
Ultramarine Blue
Phthalo Blue
Titanium White
BRUSH
Wide Flat Synthetic Hair
SUPPORT
Paper for acrylic paint

Acrylic gel looks like a white paste, but it dries transparent. When it is mixed with paint, it increases its body (and also its transparency) without the need to use a large amount. This exercise is about creating a work with a lot of relief but not very much color.

1. Make a simple drawing of the plant. Go over the outlines of the stem and the leaves with permanent green mixed with yellow and a large amount of gel.

Permanent Green + Cadmium Yellow

2. The color of the flowers is a mixture of red and yellow with some gel.

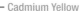

Cadmium Yellow

3. When the colors have dried, paint some areas of magenta and yellow over the plants. The gel makes very transparent colors, even when they are very thick.

Phthalo Blue

4. Add two bands of blue, ultramarine and phthalo blue. The result is reminiscent of old illustrations in medieval manuscripts.

Ultramarine Blue

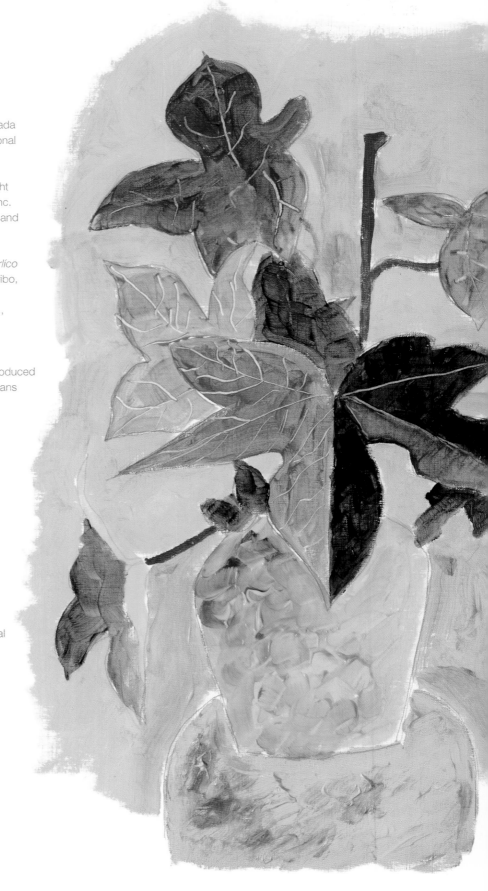

First edition for the United States, its
territories and dependencies, and Canada
published in 2014 by Barron's Educational
Series, Inc.

English-language translation © copyright
2014 by Barron's Educational Series, Inc.
English translation by Michael Brunelle and
Beatriz Cortabbaria

Original Spanish title: *101 Técnicas Acrlíco*
© Copyright 2013 by ParramónPaidotribo,
S.L.—World Rights
Published by ParramónPaidotribo, S.L.,
Badalona, Spain

All inquiries should be addressed to:
Barron's Educational Series, Inc.
250 Wireless Boulevard
Hauppauge, NY 11788
www.barronseduc.com

ISBN: 978-1-4380-0336-8

Library of Congress Control Number:
2012955780

Production: Sagrafic, S.L.
Editorial Director: María Fernanda Canal
Editors: Maricarmen Ramos
Text: David Sanmiguel
Exercises: David Sanmiguel and
Mercedes Gaspar
Corrections: Roser Pérez
Collection Design: Toni Inglès
Photography: Estudi Nos & Soto
Layout: Estudi Toni Inglès

Printed in China
9 8 7 6 5 4 3 2 1